LOS ANGELES TELEVISION

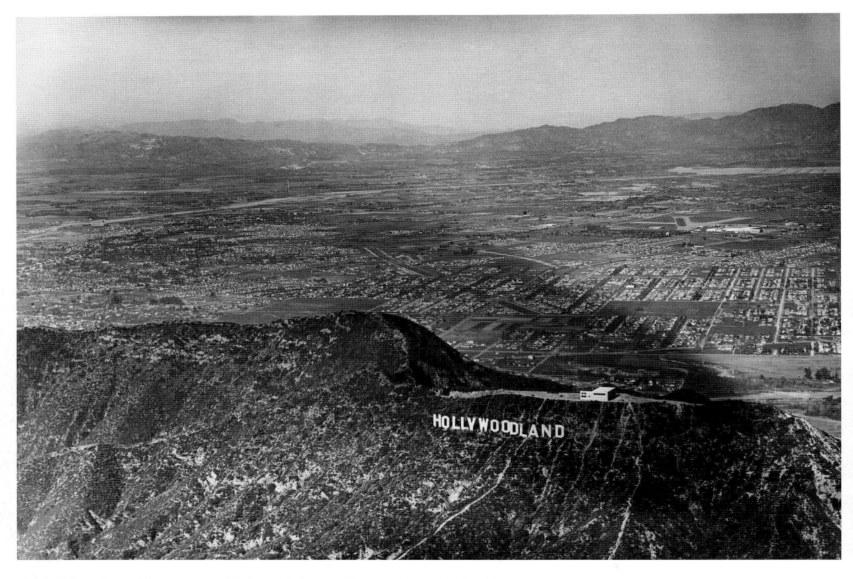

The building pictured here atop the Hollywood sign would make local television history. (Author's collection.)

ON THE FRONT COVER: Los Angeles television pioneers gather for a taping celebrating the first 35 years of local television. They are identified on page 163. (Courtesy of KTLA/Tom Hatten.)

ON THE BACK COVER: KTLA covered the first televised atom bomb detonation live. The story continues on page 127. (Courtesy of KTLA.)

LOS ANGELES TELEVISION

Joel Tator
With the Museum of Broadcast Communications
Foreword by Tom Brokaw

Copyright © 2014 by Joel Tator with the Museum of Broadcast Communications
ISBN 978-1-4671-3270-1

Published by Arcadia Publishing
Charleston, South Carolina

Printed in the United States of America

Library of Congress Control Number: 2014942580

For all general information, please contact Arcadia Publishing:
Telephone 843-853-2070
Fax 843-853-0044
E-mail sales@arcadiapublishing.com
For customer service and orders:
Toll-Free 1-888-313-2665

Visit us on the Internet at www.arcadiapublishing.com

Dedicated with love to the men and women of Los Angeles television who helped fill the Southern California airwaves with entertainment and news since 1931

Contents

Foreword		6
Acknowledgments		7
Introduction		8
1.	The Experimental Days	9
2.	That's Entertainment	19
3.	Not for Kids Only	89
4.	The News Wars	109

FOREWORD

When local television began to explode across America in the mid-1960s, with a new generation of anchors, producers, and promoters, Southern California was a separate universe with its own culture, rules, and goals.

First, it was sprawl with no single defining center. Millions of people, most of who had immigrated to California in the postwar years, spread across thousands of square miles.

It was a challenge that depended on speed and mobility, so local stations had fleets of helicopters, motorcycles, and fast cars to get the film (yes, film) back to the station in those pre-satellite days. I often flew up to the San Francisco area in the morning to cover Haight-Ashbury or the free speech movement and got back to Burbank in time for the 6:00 p.m. news.

Because it was the entertainment center of the world, the local veteran anchors were not far removed from the studio culture. George Putnam on KTLA was larger than life, an outspoken conservative well before Fox News. Baxter Ward on KABC-TV was a master of the one-on-one style and the populist stories of the day. Clete Roberts was never without his Ray-Bans, his passport, and his stylish affability. Jerry Dunphy on the CBS station was the ratings leader with a leading-man's looks and a Rolls Royce as his car of choice.

As that began to change, a new generation of television journalists earned their stripes in Southern California, including yours truly, Tom Snyder, Bryant Gumbel, and Joe Benti. Simultaneously, the local news culture developed a new generation of the multiethnic character of the area, as well as a special focus on women.

Like the area itself, Southern California and local news has always been a dynamic presence in the land of natives and immigrants, showbiz and world-class universities, surf and mountains, and deserts and fertile valleys.

—Tom Brokaw

ACKNOWLEDGMENTS

Thank you to Bruce DuMont of the Museum of Broadcast Communications in Chicago for suggesting this project and Alyssa Jones and Mike Litchfield of Arcadia Publishing for overseeing it. Ellen Deutsch painstakingly made it look right.

I am grateful to Tom Brokaw, who kindly wrote the foreword in the midst of his busy schedule.

For their contributions and permissions of many of the stills, I thank John Moczulski of KTLA, Erin Chase and David Ziedberg at the Huntington Library, Jeff Pirtle at NBC Universal, Nora Bates at the Television Academy, Betty White, Jeff Witjas, David Schwartz, Bruce Henstell, Jerry Zelinger, Mitch Waldow, Marc Wanamaker, and Jake Lau. Unless otherwise noted, all images are from the author's collection.

For their invaluable support and help on the KTLA and KNXT anniversary shows, from which some stories in this book are excerpted, I am eternally grateful to Steve Skinner, Bonnie Tiegel, Matthew Pomeranz, Chip Bell, David Shipman, Evelyn De Wolfe, Cleve Landsberg, Scott Owens, and Tom Hatten.

At KTLA, thank you to the people who helped create the history: Gary Markas, Stan Chambers, Eric Spillman, Nick Van Hoogstraten, Steve Bell, Greg Nathanson, Terry Drinkwater, Warren Cereghino, Joe Quasarano, Ron Gaviati, Jay Wilson, Ron Major, Steve Dichter, Dave Moore, Gary Reyes, Dave Lopez, Dick Watson, Dick Lane, John Polich, Ed Resnick, Sam Rubin, Robert Dean, Ray Figelski, Ray Brune, Mike Conley, Pete Noyes, Bob Tarlau, and Rich Goldner.

At KNXT/KCBS, thank you to the following: Steve Edwards, Melody Rogers, Connie Chung, Larry Forsdick, Bill Stout, Bob Heitmann, Ralph Story, Larry Greene, Jay Strong, Pam Whitfield, Dan Gingold, Jack Chapman, Mike Hernandez, and Mike Herzmark.

At NBC, thank you to the following: Jess Marlow, Lee Schulman, Mort Werner, George Falardeau, Chris Watt, Peter Nichol, Jim Mancuso, and Kelly Lange.

Thank you to these longtime friends who sustained me: Tom Snyder, Gary Greene, Jack Terry, Julian Wolinsky, Mike Alcalay, Bruce McKay, Doug Grant, Mike McManus, and Rory Markas.

My deepest appreciation goes out to the finest writers I know: Bruce Cohn, Bob Irvine, and Nate Kaplan.

I would also like to extend my gratitude to *TV-Radio Life* magazine and its staff, who were always way ahead of their time.

I could not have completed this endeavor without the inspiration of brilliant videographers Van Carlson, Gary Caplin, Tony Zapata, and Mike Armijo, who took my dreams and transported them to the television screen.

Finally, everlasting thanks goes to my parents, Frances and Maurice, who, among many other blessings, moved our family out to Los Angeles. A thanks also goes to my brother Steve, who helps me make it through life.

—Joel Tator

INTRODUCTION

In 1927, an inventor living in Los Angeles, Philo T. Farnsworth, created the first electronic television system in his home lab on New Hampshire Street in East Hollywood. He succeeded in transmitting a television picture of a young man. That first television star was Cliff Gardner, Farnsworth's brother-in-law. In 1927, Prohibition was in full swing, and the Los Angeles Police Department once raided Farnsworth's lab because it thought he was making illegal whiskey. Prohibition finally would go away, but television was here to stay.

Today, viewers in Los Angeles have hundreds of television channels to choose from. But in the beginning, there were only seven stations to watch. KTLA Channel 5 was the first to become a commercial station on January 22, 1947.

Generally speaking, most radio and television call letters began with a "K" west of the Mississippi and "W" in the east. The abbreviation "TLA" stood for Television Los Angeles. The next channel, which went live on May 6, 1948, was KTSL Channel 2. Those call letters, "TSL," stood for Thomas S. Lee, the son of car dealer Don Lee who owned the station. Third was KLAC-TV Channel 13 on September 17, 1948. "LAC" stood for Los Angeles, California. On October 6, 1948, KFI-TV Channel 9 came on the air. "FI" stood for Farm Information, which its radio counterpart was originally known for. KTTV Channel 11 signed on January 1, 1949, with the broadcast of the Rose Parade. "TTV" stood for Times Television, as 51 percent of that station was owned by the *Los Angeles Times*, with the other 49 percent owned by CBS. KNBH Channel 4 signed on January 16, 1949. "NBH" stood for National Broadcasting Hollywood. The last of the original seven Los Angeles stations was KECA-TV Channel 7, which went live on September 16, 1949. It was owned by ABC, who bought KECA radio from auto dealer Earle C. Anthony; the call letters included his initials.

There were so many stations signing on across the country the Federal Communications Commission could not keep up with the demand. In 1948, the organization suspended approvals for new construction permits. The freeze was supposed to last only six months, but it was not lifted until 1952. The next station to sign on in Los Angeles, KMEX Channel 34, did not go on air until September 30, 1962.

OPPOSITE: The history of Los Angeles television started on May 10, 1931, on the eighth floor of a Cadillac dealership in downtown Los Angeles. That day, engineers, utilizing Farnsworth's research systems, sent a television picture from one side of the room to the other.

One
The Experimental Days

Cadillac dealer Don Lee, who owned radio station KHJ, became interested in seeing what television was all about. He heard about a 25-year-old Farnsworth engineer named Harry Lubcke and hired him. A transmitter was built atop the dealership, and experimental station W6XAO went on the air on December 31, 1931. It broadcast one hour a day to the five television sets in the area. The first programming included old newsreels and outtakes from feature films. In 1933, the station broadcast footage of the Long Beach earthquake, the first breaking news on television. The station built a small studio on the second floor so it could use performers. There were poetry readings to music. Also, in 1933, the first feature film ever shown on television, *The Crooked Circle with Zasu Pitts*, was presented. On April 15, 1938, the first soap opera was broadcast. *Vine Street* was the story of a young woman trying to build a career in Hollywood. It ran for 15 minutes twice a week. Realizing the company would eventually need more studio space and a better transmitter site, in 1939, Don Lee Broadcasting bought a 20-acre site atop Mount Cahuenga in the Hollywood Hills. On December 23, 1940, the studio and transmitter were completed, and Mount Cahuenga was renamed Mount Lee, in honor of Don Lee, who had died in 1934.

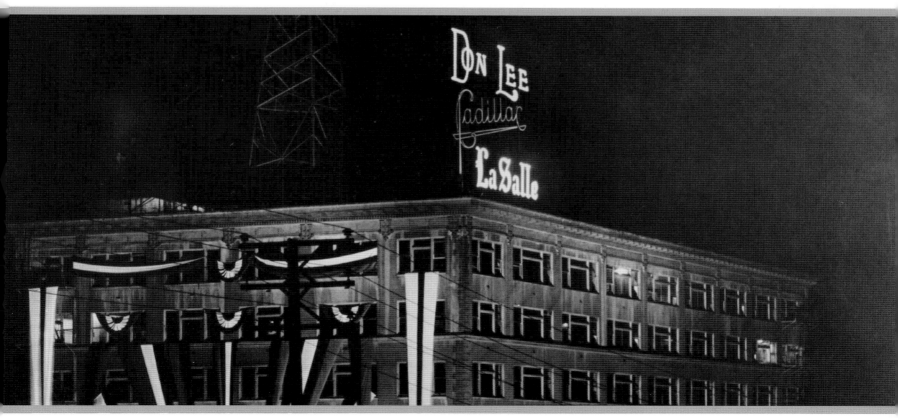

Below the new building was the huge Hollywoodland sign, which was an advertisement for a real estate development. The last four letters were removed in 1949. At 1,700 feet in elevation, the top of the mountain afforded views of both the city and the San Fernando Valley. (Courtesy of the Bruce Torrence Hollywood Historical Collection.)

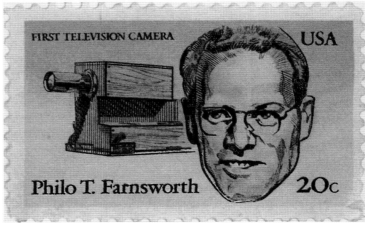

This stamp honors television inventor Philo T. Farnsworth. (Courtesy of USPS.)

THE EXPERIMENTAL DAYS

The single stage was 100 feet by 60 feet, and a swimming pool was constructed for water shows. Television programming from the new building was put on hold at the beginning of World War II, and the facilities were used to broadcast civil defense programs and war bulletins. By 1946, it was estimated there were 400 television sets in the Los Angeles area. On September 30, 1946, a tennis court was set up in the studio and the first televised tennis match took place. (Both from the "Dick" Whittington Studio, courtesy of the Huntington Library, San Marino.)

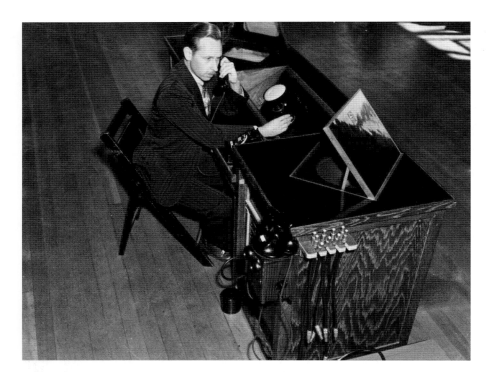

Chief engineer Harry Lubcke is pictured here at a video console.

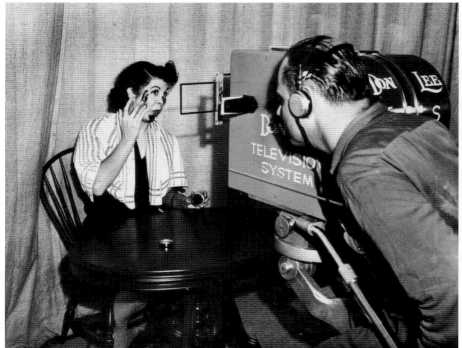

An actress applies dark makeup to her face, made necessary because of the intense studio lighting and sensitive camera tubes. (From the "Dick" Whittington Studio, courtesy of the Huntington Library, San Marino.)

THE EXPERIMENTAL DAYS

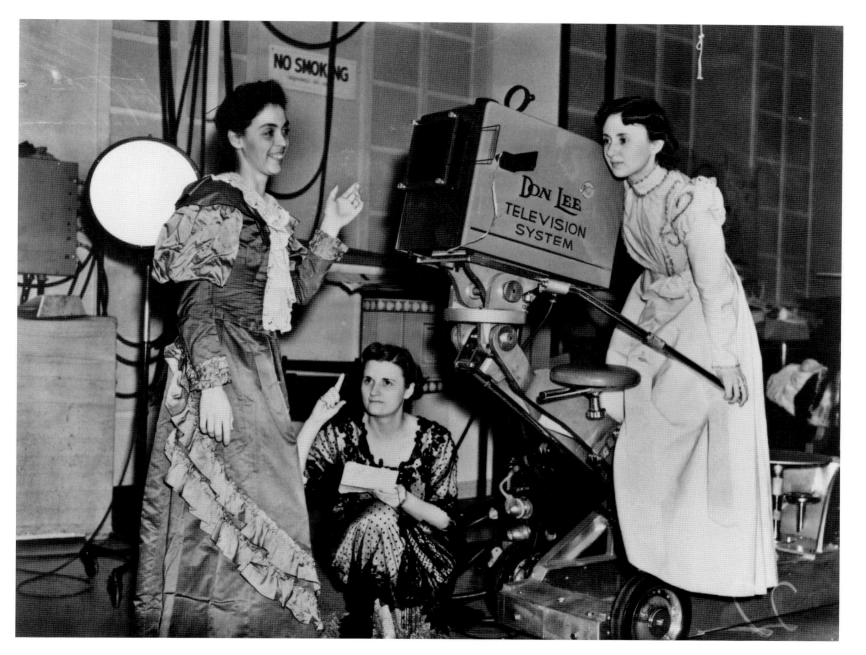

Posing here is an all-female production crew at the Mount Lee Studio. Note the simple tin viewfinder attached to the side of the camera. (Courtesy of Bruce Henstell.)

LOS ANGELES TELEVISION

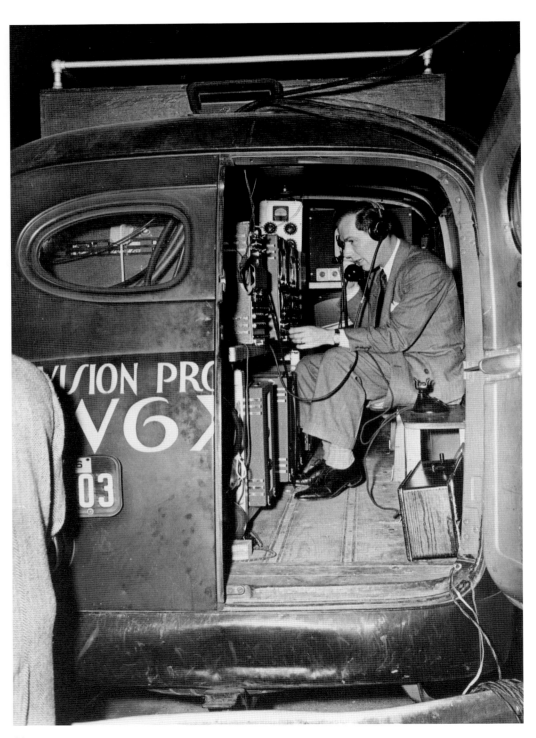

In 1936, the world's first regular television service began in London from Alexandra Palace. That same year, the Olympics in Berlin were televised by the Germans. There was a strong Los Angeles connection, as one of the German engineers working on that coverage was a 20-year-old student named Klaus Landsberg, a proven electronic boy genius. At 16, he had built the world's most effective shortwave radio. After the Olympics, Landsberg and his family, seeing what Nazi activity was taking place, moved to America. He soon got a job with RCA when RCA's NBC introduced television service to America at the 1939 New York World's Fair. In 1941, Paramount Pictures, wanting to get into television, heard about Landsberg. The company hired and sent him to Los Angeles to put something together. (Courtesy of KTLA.)

THE EXPERIMENTAL DAYS

With two suitcases filled with electronic bits and pieces, Klaus Landsberg arrived at the Paramount Studios in Hollywood. At age 25, he started experimental station W6XYZ. He chose the optimum spot on Mount Wilson above Pasadena for his transmitter. In September 1942, W6XYZ went on the air. The only place Paramount had for its fledgling television operation was a garage just outside the DeMille gate at Bronson Avenue and Marathon Street. The station broadcast two nights a week. There were two small studios crammed into the garage, but Landsberg wanted to take his camera outside the studio, so he built a remote truck. The first remote was not very far away.

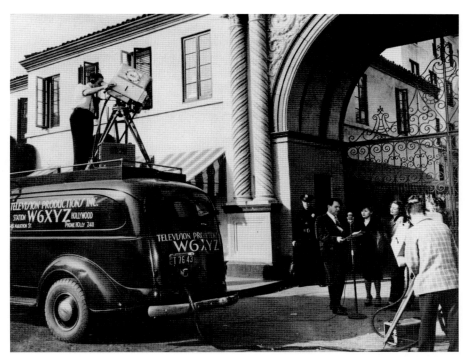

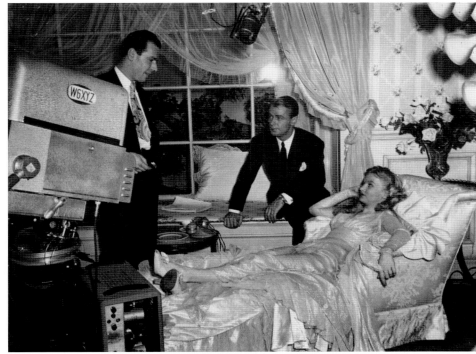

Klaus Landsberg took cameras to a Paramount stage to watch them filming a scene from *This Gun for Hire*. He is seen here with Alan Ladd (seated) and Veronica Lake. (Courtesy of KTLA.)

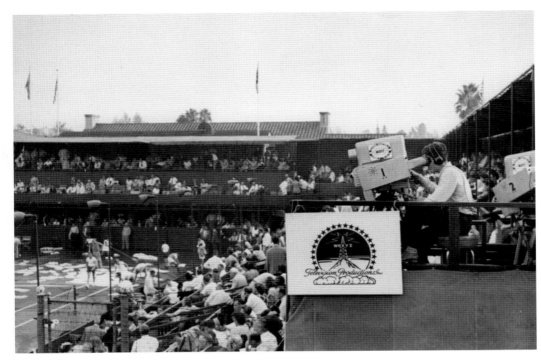

Local sporting events were televised, like the tennis matches at the Los Angeles Tennis Club, pictured at left, and starting in 1945, wrestling from the Olympic Auditorium was broadcast. Landsberg hired movie actor Dick Lane to call the matches. Lane was the first of a stock company put together whose versatility and personality allowed the station to present sports, news, entertainment, and commercials.

There was also a nightly newscast as well as a program called *Shopping at Home*, where various items were shown to viewers who could then call in and order them. (Courtesy of KTLA.)

THE EXPERIMENTAL DAYS

The station also got involved in local issues. On September 5, 1946, W6XYZ produced a special called *Do We or Don't We Want the Hollywood Freeway?* The program card, seen in this photograph, was mailed out each week to the few hundred people who had written to the station to say they were watching. This practice continued until 1949, when the mailing list expanded greatly.

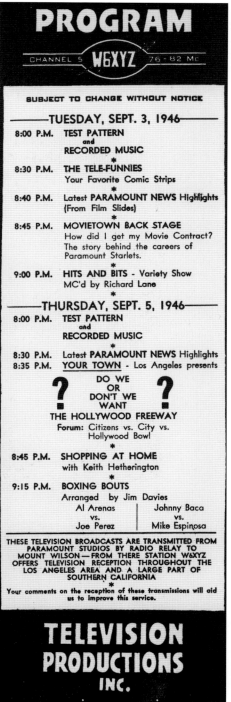

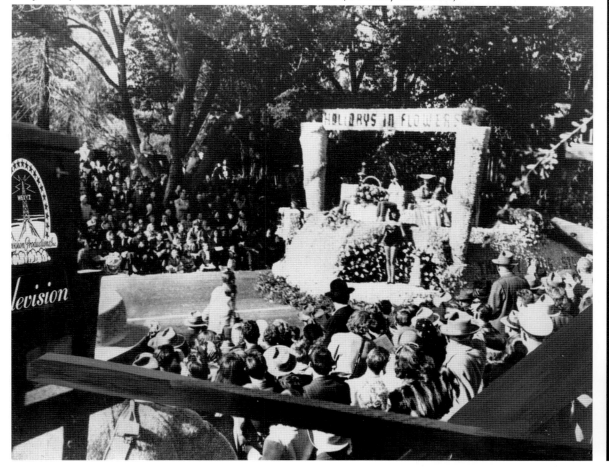

On January 1, 1947, W6XAO televised its first Rose Parade. (Courtesy of KTLA.)

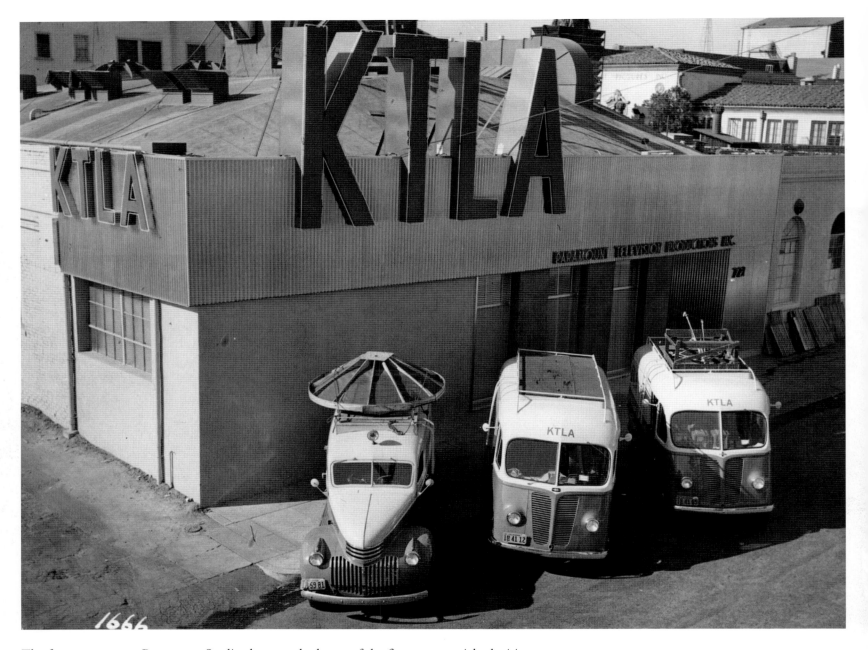

The former garage at Paramount Studios became the home of the first commercial television station in the West, and W6XYZ became KTLA Channel 5. (Courtesy of KTLA.)

Opposite: *Queen for a Day*, a popular radio program, comes to television in 1948 on KTSL Channel 2, the former experimental station W6XAO. *Queen* would later move its television version to NBC and then ABC. (Courtesy of Bruce Henstell.)

Two
That's Entertainment

On January 22, 1947, the show business trade paper *Daily Variety* printed the story of the impending premiere of West Coast commercial television; however, it was not front-page news. It was reported on the bottom of the sixth page, next to the story about Meyer Gerson retiring as head of the commissary at Universal Studios. It is estimated there were approximately 4,300 television sets in the Los Angeles area, and many of them were handmade. Some appliance stores would leave their television sets on after closing time to offer passersby a glance at the new invention. The screen sizes were 12 inches.

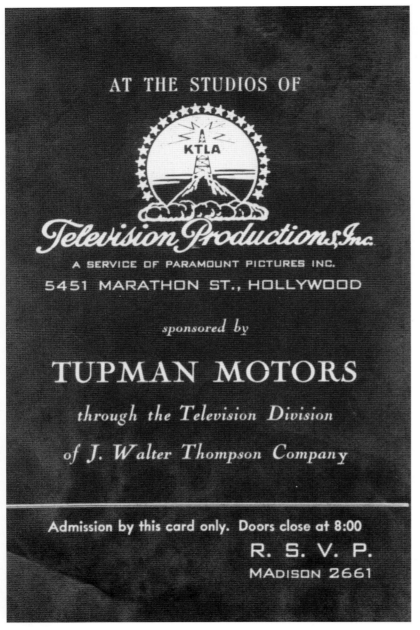

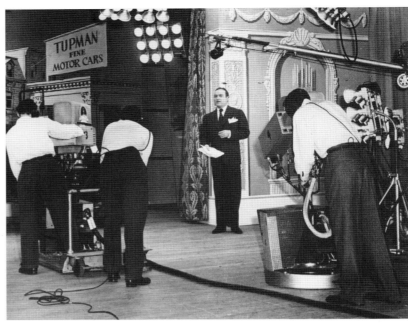

After mistakenly calling Channel 5 "KTL," Bob Hope looks at the three large television cameras facing him and asks, "All I want to know is which one picks up the smell?" There is no kinescope recording extant of the historic broadcast, but the Paramount Newsreel sent over a crew to document the event. The footage was never shown in movie theaters as part of the twice-weekly newsreels. Perhaps Paramount was afraid of what might be coming as television started to take hold of America. (Courtesy of KTLA.)

The KTLA inaugural program was held on Paramount's Stage 3 before an invited audience. The program was sponsored by Tupman Lincoln-Mercury, whose live advertisements would be the very first on Los Angeles commercial television. The show opened with remarks by director Cecil B. DeMille, who then introduced host Bob Hope (above, right).

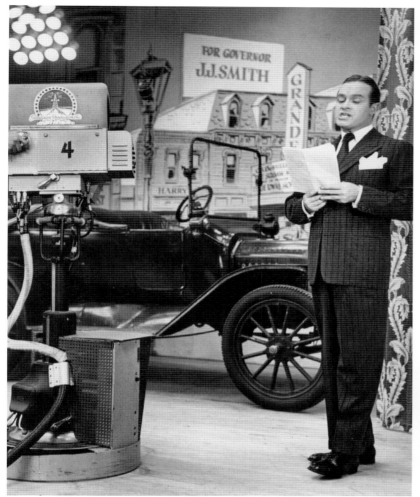

The day after the premiere broadcast, the trade papers were not kind to the debut. The *Hollywood Reporter* stated, "Commercial Video Test by Paramount fails to impress. It is very doubtful if last night's presentation inspired in a single viewer the desire to buy a video receiver." *Daily Variety* put it this way: "Commercial television's debut here rated low as programming. It looked like the answer to the question 'What happened to vaudeville?'"

A young man just out the Navy applied for a job at KTLA on December 1, 1947. At first, he was assigned to build sets and work on the stage crew. One day, Evelyn De Wolfe, the wife of station manager Klaus Landsberg, noticed the young man and said to Landsberg, "What's that good looking guy doing in the back room all the time . . . he should be in front of the cameras." That was the beginning of Stan Chambers's on-the-air career. Soon, he became part of the KTLA stock company of performers, presenting news, entertainment, and commercials and announcing. In a record unequalled in broadcasting, Chambers would spend the next 65 years at KTLA. (Courtesy of *Televiews*.)

One of KTLA's first hit shows was *Meet Me in Hollywood*, originating from the corner of Hollywood Boulevard and Vine Street. It began on October 25, 1947, and is considered the first so-called "man-in-the-street" television show. It was hosted by Bill Welsh, who had been hired in 1946, and he was later joined by Stan Chambers. (Courtesy of KTLA.)

At KTLA, Bud Stefan (second from right), a friend of Stan Chambers, got a part-time job as a stagehand. One day, Stefan was joking with some of the other crew members as Klaus walked by. Klaus liked Stefan's relaxed personality. "You go on Friday night," he told the shocked Stefan. The program *Yer Old Buddy* featured Stefan and Joe Flynn, who used the half hour to humorously explain what this new thing called television was all about. Produced and written by Stefan, it began in August 1948 and ran for four years. One of the early cast members was an unknown actress named Norma Jean Baker. She would later change her name to Marilyn Monroe. (Courtesy of KTLA.)

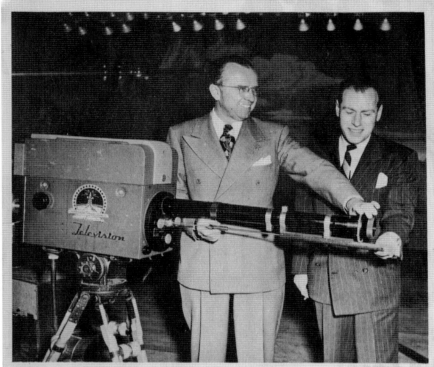

Television NEWS

KTLA INAUGURATES ZOOMAR LENS ON ROSE BOWL GAME AND PARADE

ZOOM!—Jerry Fairbanks (left), co-developer of the Zoomar lens, and Klaus Landsberg, West Coast director of Para Television, give the magic lens a thorough going-over before the Rose Bowl game. Zoom quality of the lens made the KTLA telecast of the Bowl game the finest sportscast accomplished so far. (Television News photo).

KTLA ESTABLISHES WEST COAST 'FIRST' WITH ZOOMAR ON BOWL

Paramount's KTLA grabbed itself a pile of well earned glory with its telecast of the Tournament of Roses Parade and of the Rose Bowl game. . . . And one of the factors accounting for the exceptional clarity and "zoom" of picture was the initial West Coast use of the Zoomar lens.

Flown here in special shock-proof crating for the New Year's Day events, the Zoomar lens was pressed into advantageous service by the KTLA crew members, who, under the tutelage of Jerry Fairbanks and Klaus Landsberg, managed the new technique in record time.

Most noticeable advantage of the lens from a tele-viewer's standpoint was its ability to "move" the camera in from a long shot to an extreme close-up—and back again, either with breath-taking speed or revealing slowness. . . . And of course the camera never actually dollied at all.

Skeptics Get Eyeful

Paramount has installed a special set-up for the doubting Tomases—those who are skeptical about it being possible to record film from the face of a viewing tube and throw it on a screen 66 seconds later—who look with a jaundiced eye on the future of television theaters.

Electric Companies To Take Television Count

If your electric bill—one of these days—comes with an added questionnaire on television, then you'll know that a national survey is in full swing. It's just the newest wrinkle in checking how many television sets are in homes and securing some of the additional information which it has been impossible to get to date.

Initial test surveys have been made in Chicago—where 12,000 television sets were found to be in home operation—and in St. Louis, which had 2,162 receivers operating in the city.

THE ANSWER to the "mystery" pictures on page 6 is the name Rufe Davis. . . . Sure, it was on the tip of your tongue all the time, wasn't it?

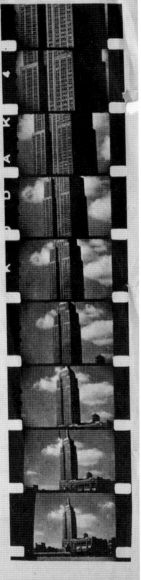

ONE LENS accomplishes this . compound zoom shot of a building. This illustrates graphically the entire range of the "Zoomar A" from 17-106mm focal length. The outstanding effect and advantage of the lens is zooming without changing the distance between the camera and the lens.

In late 1947, KTLA received the first Zoomar lens on the West Coast. Jerry Fairbanks, codeveloper of the lens, delivers the product to Klaus Landsberg in this image. It arrived just in time for the station's coverage of both the 1948 Rose Parade and Rose Bowl game. The lens went from 17 to 106 millimeters. Previously, multiple lenses on a turret had to be used to get the same range of shots. (Courtesy of *Television News*.)

Producer Mike Stokey brought two programs to KTLA. The first was *Pantomime Quiz,* which featured celebrities trying to guess charades and began January 18, 1948. Panelist composer Frank DeVol recalls the program was sponsored by Gold Medal Flour, and in lieu of payment, the guests received bags of noodles. When Ronson joined the sponsors, panelists received lighters. Pictured from left to right are Frank DeVol, Hans Conreid, Vincent Price, Joan Caulfield, Sandra Spence, Mike Stokey, Marilyn Maxwell, and Marie Windsor. (Courtesy of *TV-Radio Life.*)

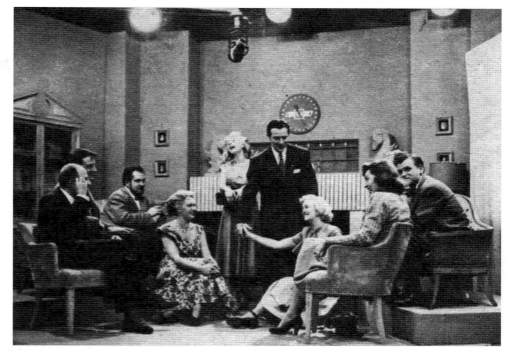

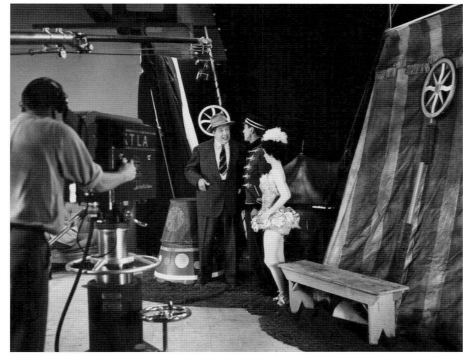

Stokey's other show, *Armchair Detective,* was a live dramatic mystery show where two whodunits containing clues were presented and then the solution was explained. The show premiered June 24, 1948, and the host, John Milton Kennedy, demonstrated the first model of the Polaroid camera on one of the episodes. Pictured is a scene from *Armchair Detective.* (Courtesy of KTLA.)

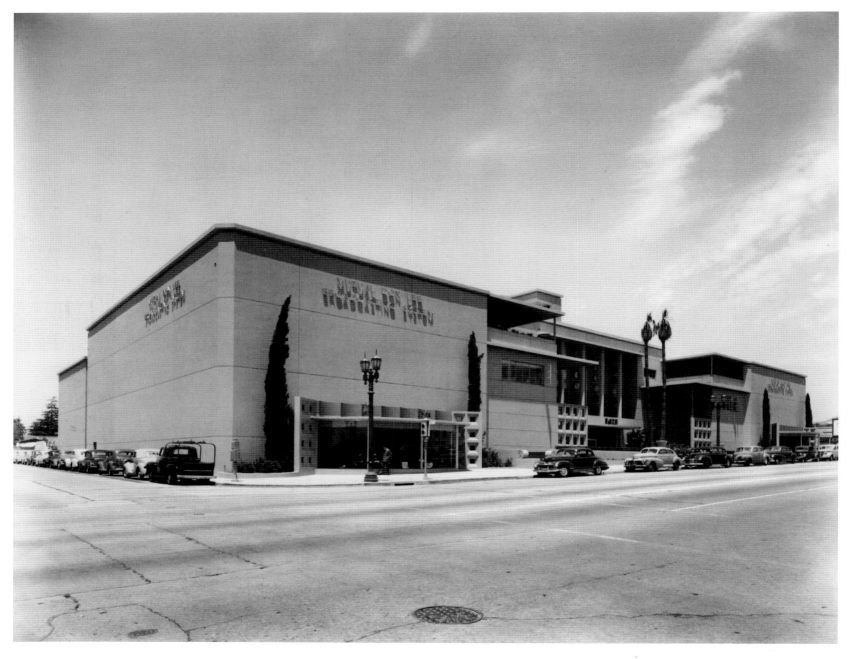

After KTLA, the next station to sign on was Don Lee's Channel 2 KTSL. It broadcast from a facility billed as the first plant built for television, an 118,000-square-foot building at 1313 North Vine Street. It contained four large audience studios and smaller radio facilities and was built at a cost of $3 million. It opened in May 1948 and is pictured here. (Courtesy of AMPAS.)

Next to open was KLAC-TV Channel 13. The station shared space with sister radio station KLAC in a hacienda-themed building near Cahuenga and Santa Monica Boulevards in Hollywood. Later, the call letters were changed to KCOP after it was sold to Copley Press. (Courtesy of Mitch Waldow.)

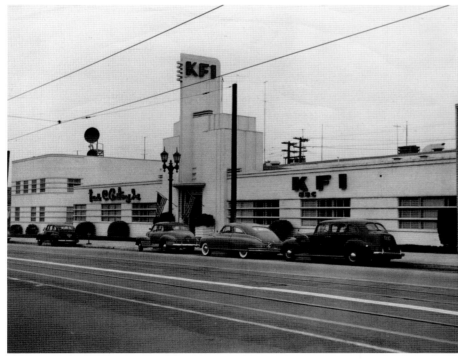

Next to start broadcasting was KFI-TV Channel 9, which was set up alongside its radio affiliate, KFI, on South Vermont Avenue. (Courtesy of Coy Watson.)

KTTV Channel 11 was next station to go live. Its first home was on the top floor of the Bekins Storage building at Santa Monica Boulevard and Highland Avenue in Hollywood. The staff members complained they had to walk in a crouch because the ceiling that supported the hanging television lights was so low. Eventually, it would move to 5515 Melrose Avenue (the old NBC radio studios) and then to an old movie lot, Nassour Studios, at Sunset Boulevard and Van Ness Avenue.

Even though KTTV Channel 11 signed on January 1, 1949, with a telecast of the Rose Parade, the formal dedication of the station took place on March 8, 1949. There was no way any kind of a large production could originate from the station's home on the top floor of the Bekins Storage building, so since KTTV was 49-percent owned by CBS, the dedicatory special originated live from Columbia Square's massive theater Studio A. The master of ceremonies was Jack Benny, and guests included the Andrews Sisters, Margaret Whiting, Bob Crosby, Lum and Abner, Eddie "Rochester" Anderson, and violinist Isaac Stern. There was an invited audience of 800. Estimates were that 350,000 people comprised the Los Angeles television audience at the time. (Courtesy of CBS Photography.)

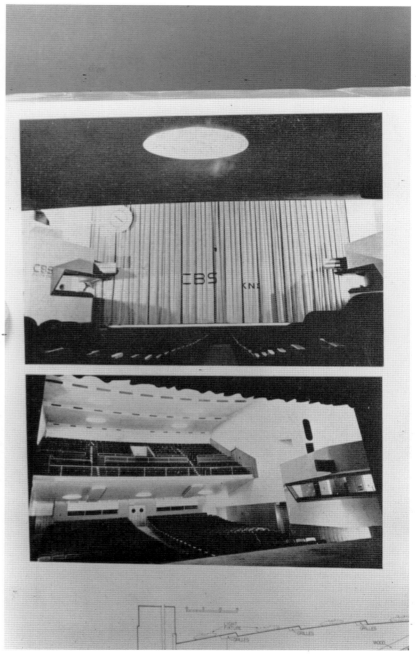

CBS Studio A at Columbia Square is seen here. In 1951, Studio A was the location of the production of the *I Love Lucy* pilot with live cameras, not film, which was used for the rest of the historic series.

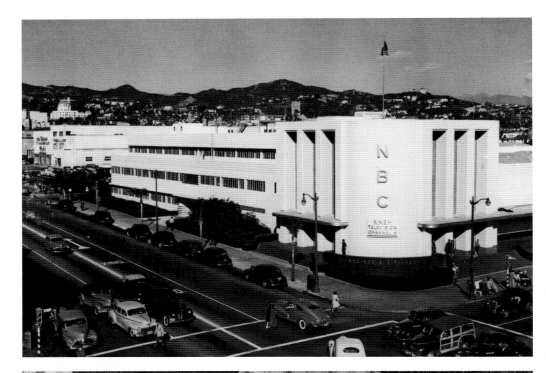

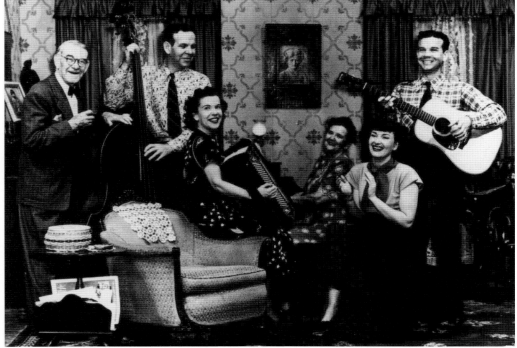

KNBH Channel 4 signed on the air from the Art Deco Radio City at the corner of Sunset Boulevard and Vine Street in 1938. Its first live show, broadcast at 7:18 p.m., was the 15-minute show *The Pickard Family*. The Pickards consisted of parents and their five kids playing bluegrass music, and they had first appeared together on the *Grand Ole Opry* radio program in 1927. KNBH took over two of Radio City's former audience radio studios. (Both, courtesy of NBC Universal Archives and Collections.)

THAT'S ENTERTAINMENT

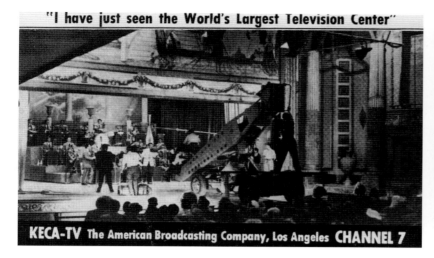

The last of the original seven Los Angeles stations to sign on was KECA-TV Channel 7. It was owned by ABC and set up shop at the former Vitaphone and Warner Bros. movie studio in East Hollywood. It was advertised as the world's largest television center in this postcard. The scene is from a broadcast of *The Lawrence Welk Show*. The audience theater utilized the set from an early version of *Phantom of the Opera*, which was filmed there. A small portion of the opera house can be seen on the right.

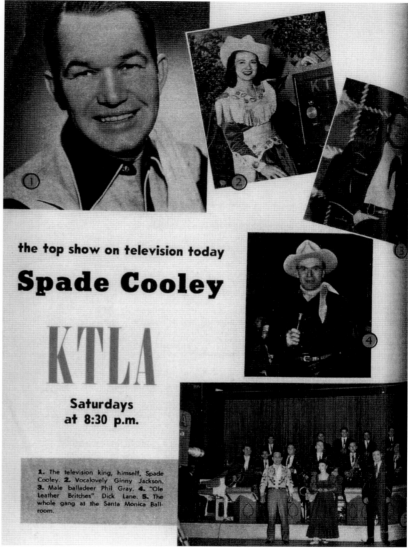

Donnell Clyde Cooley, a country-western bandleader and fiddle player known as Spade Cooley, was 38 years old in 1948. A stand-in for Roy Rogers in some films, he had been performing at the Santa Monica Ballroom on the pier to large, enthusiastic crowds. Klaus Landsberg thought he could turn that appeal into a weekly television program. On August 5, 1948, a Saturday night, *The Spade Cooley Show* (then called *The Hoffman Hayride*) premiered. Soon, it became the most popular show on Los Angeles television. The format was simple: some swing music, guest stars, specialty acts, and comedy, all hosted by Cooley. Dick Lane handled the commercial duties. (Courtesy of *TV-Radio Life*.)

The Spade Cooley Show was in the top ten ratings for four years and lasted until 1957.

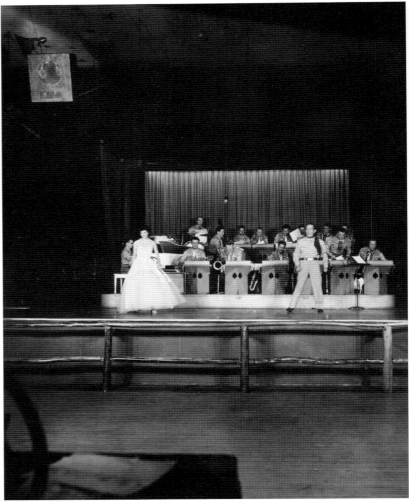

Spade Cooley had a troubled personal life, and on April 3, 1961, he murdered his wife. He was sentenced to life in prison but was scheduled to be paroled in 1972. On November 23, 1969, he received a 72-hour furlough so he could perform one more time at a benefit in Oakland. After his number, he received a standing ovation. The curtain closed, and he died of a heart attack. He was 59 years old. (Courtesy of KTLA.)

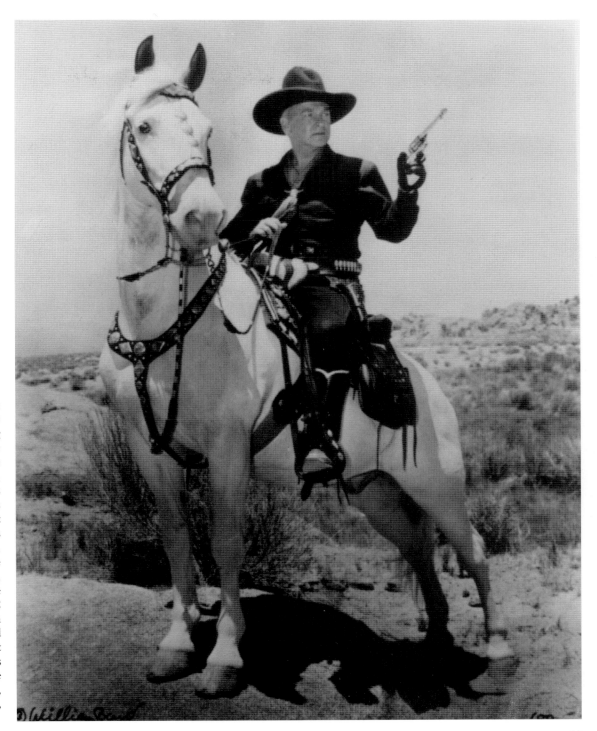

William Boyd was a silent movie actor whose star had faded, but in the mid-1930s, he was selected to play Western hero Hopalong Cassidy in a series of B-movies. "Hoppy" wore all black and rode a white horse, and the role made Boyd famous again. One day in 1948, he asked a colleague if motion picture films could run on television. When the answer was "yes," Boyd borrowed $350,000 and bought up the rights to the 66 Cassidy movies. His first sale was to KTLA, and on August 7, 1948, *Hopalong Cassidy* hit television. The films were edited down to one hour each, and soon, the programs were the number-one television show in Los Angeles. The NBC network picked them up but could not run them in Los Angeles because Landsberg had the local rights. Seeing a goldmine, Boyd went back into the studio and made new episodes just for television. Soon, Hoppy merchandise made more money for Boyd than the films, and he even opened an amusement park, Hoppyland, in Venice, California.

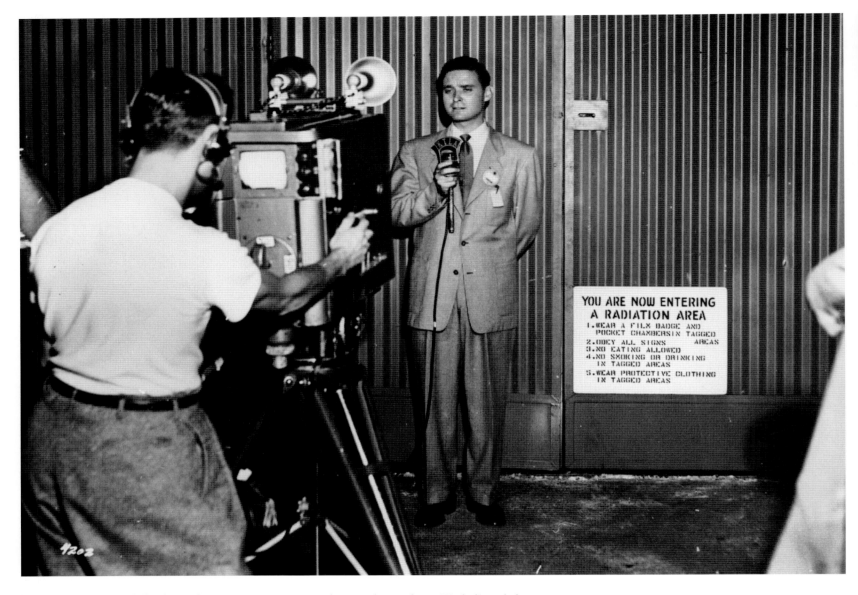

Klaus Landsberg took his live television cameras everywhere and anywhere. He believed that television was about showing viewers what was going on in Los Angeles at the moment those events were taking place. Whether it was news, sports, entertainment, or public affairs, viewers could sit in front of their sets and experience it all. In 1949, KTLA began a show called *City at Night*. The concept was to take a camera to something that was going on that night. It could be a tour of a factory or a movie studio, a fireworks show, the *Ice Capades*, a party, or a police station. In the beginning, Dorothy Gardiner and Keith Heatherington, part of Landsberg's stock company of performers, were the hosts, and then Ken Graue, pictured here on location, took over. (Courtesy of KTLA.)

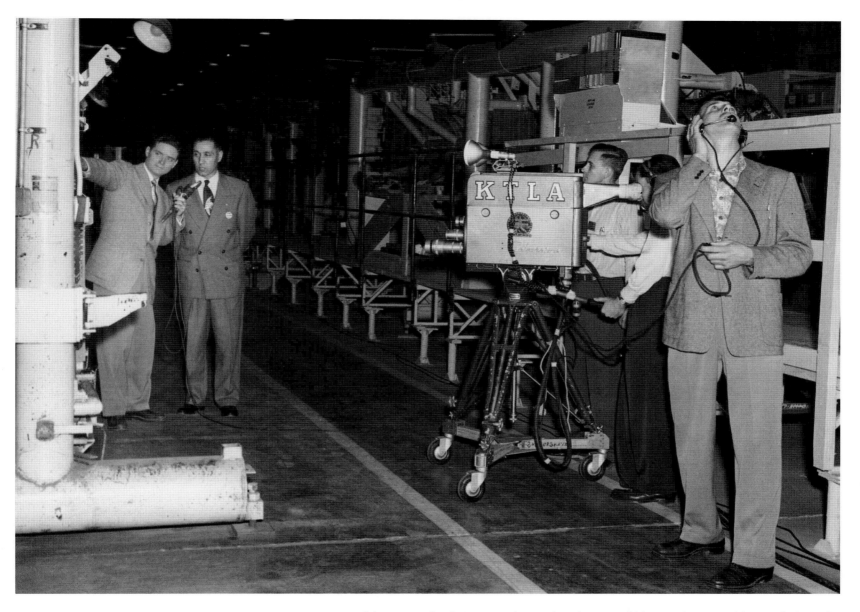

Part of the gimmick of *City at Night* was that there would be no advance publicity of where the show would be broadcast. The crew did not even know until it was time to leave the Bronson studio and head out. One night, Graue was late and missed leaving with the remote trucks, so he had no idea where to go. Finally, an angry Landsberg called the station and told Graue where that night's show was—the Sparkletts water plant. Graue made it just in time to broadcast. The show ran until 1957 and was briefly revived in 1962 as a taped program with Bill Stout as host. In this photograph, the show is being broadcast from the Northrop Aircraft plant. At left is host Ken Graue, and at right is stage manager John Polich. (Courtesy of Northrop Aviation.)

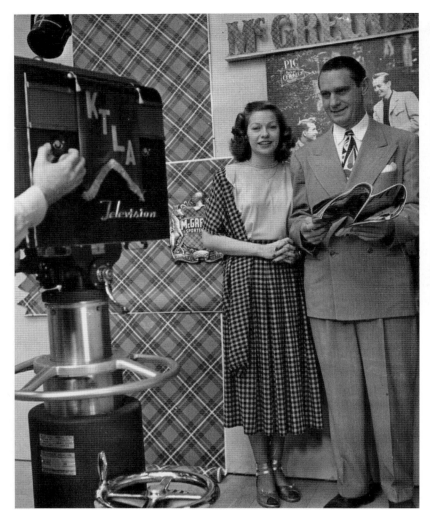

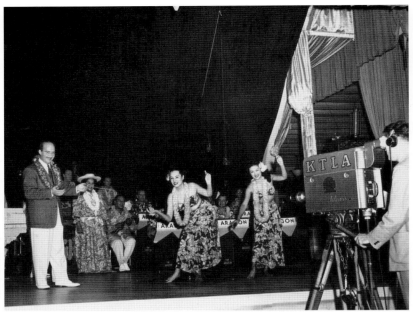

Another hugely popular program was *Harry Owens and His Royal Hawaiians*, which originated live each Friday night from the Aragon Ballroom on Santa Monica's Lick Pier. The program featured mostly Hawaiian music and performers, including Hilo Hattie, seen next to Owens (left). The theme song of the show was "Sweet Leilani," which Owens wrote and won an Academy Award for Best Song. The show began in March 1949 and eventually moved to Channel 2. (Courtesy of KTLA.)

Dorothy Gardiner and Keith Hetherington were two more members of Klaus Landsberg's stock company of on-air performers. In early 1949, they were together hosting *Shopping at Home*, which, on May 2, 1949, turned into the 15-minute *Handy Hints*. People wrote in with ways to save money and make things easier. One of the most popular elements of the show was a knock-knock joke submitted by viewers. Dick Garton eventually replaced Hetherington. (Courtesy of KTLA.)

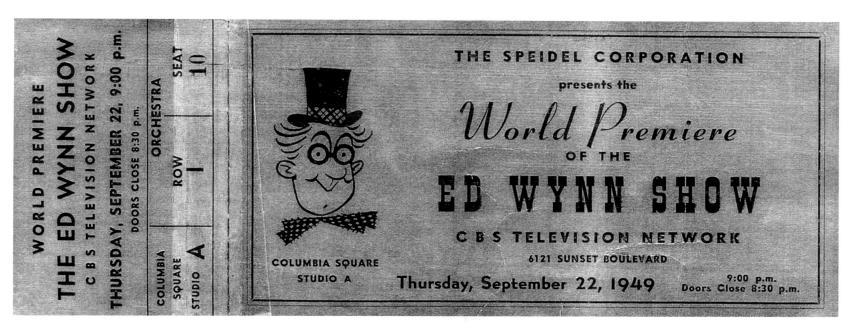

On September 22, 1949, the first CBS television network program to originate in Los Angeles began at Columbia Square Studio A in Hollywood. It was *The Ed Wynn Show*, a half-hour comedy variety program. This was also the first television production to take place at Columbia Square, which previously only held radio shows. The program was seen live in Los Angeles but was kinescoped for the rest of the country to be seen a week later. Because this was the first of its kind, the show ran long, and the kinescoped version had to be edited down to 30 minutes, necessitating some jarring edits.

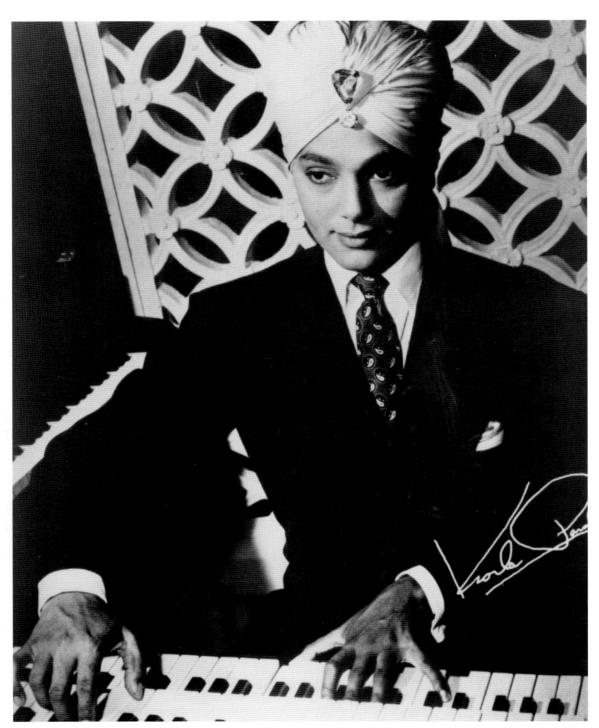

John Redd, an African American piano player, was born in 1921 in St. Louis. In the mid-1940s, he and his wife moved to Los Angeles to get into broadcasting. His career was not going well at the time, and he decided to reinvent himself as Korla Pandit from New Delhi, India. In 1949, he was playing at a fashion show being televised by KTLA. Klaus Landsberg liked his appearance and offered him a job playing the organ for 15 minutes on Sunday afternoons under two conditions: Pandit could never speak, and he would have to play the organ for KTLA's new kids' show *Time for Beany*. In February 1949, *Musical Adventures with Korla Pandit* premiered. In over 900 shows, Pandit never spoke. It was only after his death in 1990 that his true identity was revealed. (Courtesy of Korla Pandit Presentations.)

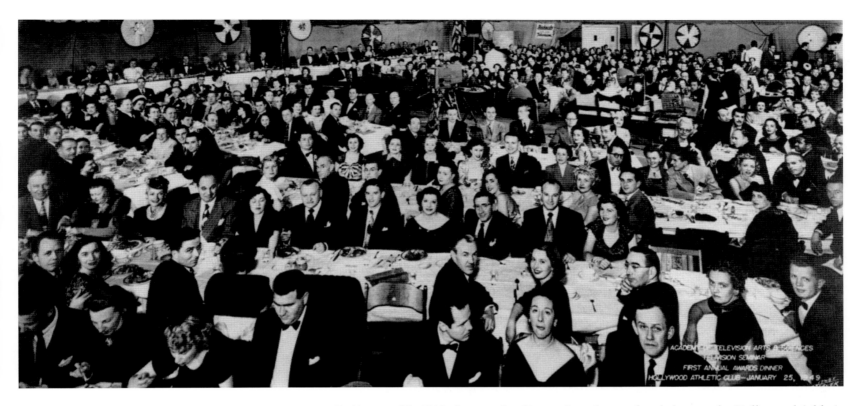

On January 25, 1949, the very first Emmy Awards were handed out at the Hollywood Athletic Club on Sunset Boulevard. The first Emmy went to ventriloquist Shirley Dinsdale as the Most Outstanding Television Personality for her show *Judy Splinters* on KTLA. The second went to *Pantomime Quiz Time with Mike Stokey*, also on KTLA, as the most Popular Television Program. The event was televised by KTSL Channel 2, but sadly, no kinescope recording survived. However, when Shirley Dinsdale found out she was nominated, she decided to take along her wire recorder. She placed it on the table where she was seated and turned it on when it was time for her category. That scratchy recording is the only audio of that first historic dinner. (Courtesy of the Television Academy.)

In the fall of 1949, Steve Allen was doing a local radio show for CBS affiliate KNX. One day, he received a call from KECA-TV, the newly signed-on ABC station. The station planned to cover the wrestling matches each week from the Ocean Park arena and was in search of an announcer who could have some fun with the sport, which was already extremely popular on its competitor KTLA. Allen put a few jokes on cards and was soon on the air. From his autobiography *Mark It and Strike It*, here was one of his calls: "Leone gives Smith a full nelson, now slipping it up from either a half nelson or an Ozzie Nelson. Leone takes his man down to the mat. He has him pinned. Now they roll. It's sort of a rolling pin." Commenting on the raucous crowd, he said, "There's a man down there giving out with boos and catcalls and if I had that much booze I'd call a few cats myself." After several months, Channel 7 replaced the matches with old movies. (Courtesy of *TV Image*.)

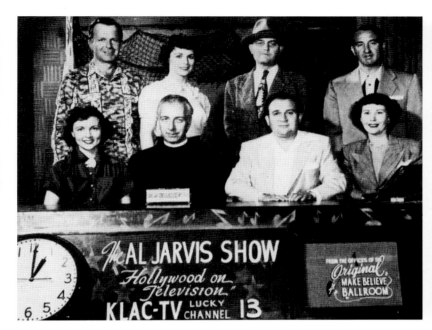

Betty White was one of early Los Angeles television's first breakout stars. She had been appearing on KLAC-TV Channel 13's game show called *Grab Your Phone* when she got a call from one of Los Angeles radio's biggest disc jockeys, Al Jarvis. He was about to start his first television show, called *Hollywood on Television*, and was looking for a girl Friday. The show would be on KLAC-TV for five hours a day, and White would be paid $50 a week for her work. The show began in November 1949. The show had only one camera and broadcast from the small studio on Cahuenga Boulevard near Santa Monica Boulevard from 12:30 p.m. to 5:30 p.m. (Both, courtesy of Betty White.)

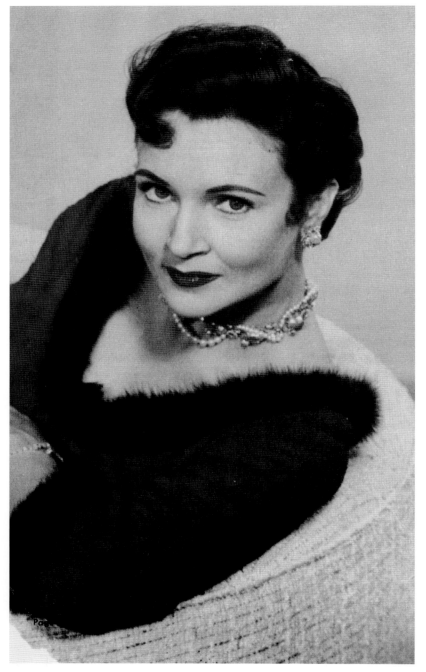
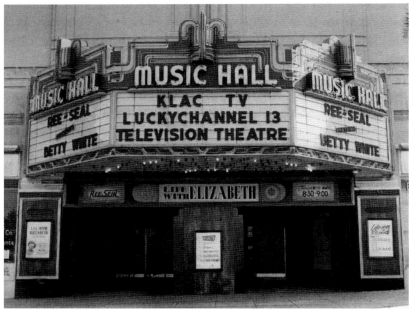

Hollywood on Television became so popular the station added another half hour, plus a five-and-a-half-hour show on Saturday. Betty White's salary was increased to $300 a week. The commercials were live, and there were as many as 58 live commercials a day. There were also no cue cards—everything had to be memorized. After a couple of years, Jarvis left to go to Channel 7, and White became the new host. That led to a live, local situation comedy called *Life With Elizabeth* that White did with Del Moore from the Music Hall Theatre on Wilshire Boulevard in Beverly Hills, where Channel 13 originated its big-audience programs. It broadcast on Saturday nights at 8:30 p.m., and after one year, it was syndicated as a filmed sitcom in 1953. (Left, courtesy of *TV-Radio Life*; above, courtesy of Betty White.)

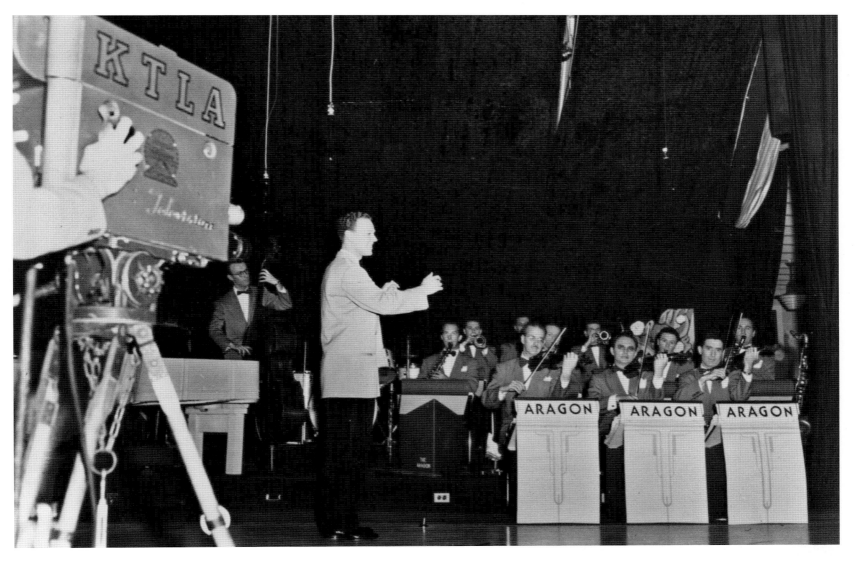

KTLA loved the beach. On December 4, 1949, Klaus Landsberg premiered a big band show from the Aragon Ballroom in Ocean Park called *Bandstand Revue.* It featured name bands each week and was hosted by singer Harry Babbit. Leighton Noble (pictured) became the regular bandleader. Never one to waste a location, Landsberg set up his cameras on the nearby beach a few hours before bringing them inside the Aragon to televise *Fun on the Beach* with Dorothy Gardiner and Stan Chambers on Sunday afternoons. In 1954, *Bandstand Revue* moved to the KTLA studios and changed formats. This time, the show featured the top-selling song of the week with 25 live production numbers in the hour, in addition to the live commercials. One week during the show, a stagehand fell while moving props and broke his leg. He laid there for the rest of the broadcast because everyone on the set too busy to help him. (Courtesy of KTLA.)

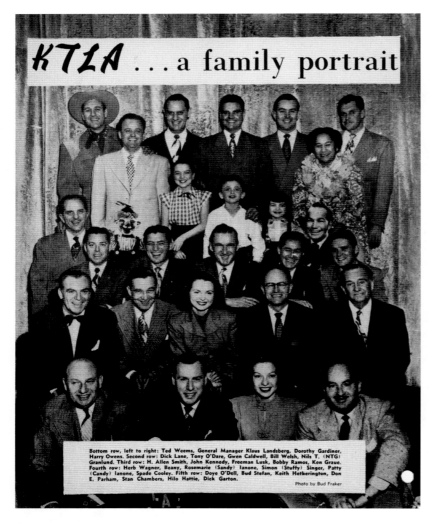

In this c. 1950 promotional image is Klaus Landsberg's stock company of performers. (Courtesy of Bud Fraker.)

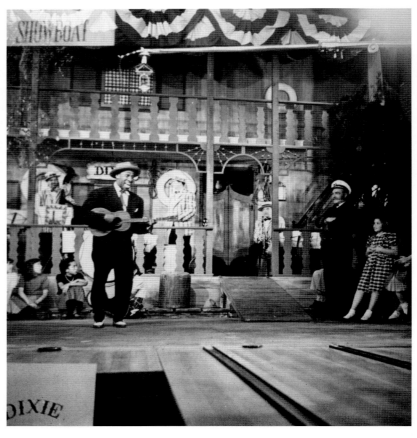

In the early 1950s, some of the entertainment on television was made up of minstrel shows. The dictionary defines them as "a troupe of performers giving a program of black American melodies, jokes and impersonations and usually wearing blackface." KTTV Channel 11's minstrel show was *McMahon's All Star Minstrels*, which premiered in 1950, broadcast from the El Patio Theatre at Hollywood Boulevard and La Brea Avenue. KTLA's more popular effort was *Dixie Showboat*, hosted by the ever-present Dick Lane as the captain of the docked riverboat. The show premiered on March 2, 1950, from the KTLA Studio Theatre. It featured some African American performers, including Scatman Crothers, but there were also white performers in blackface. (Courtesy of KTLA.)

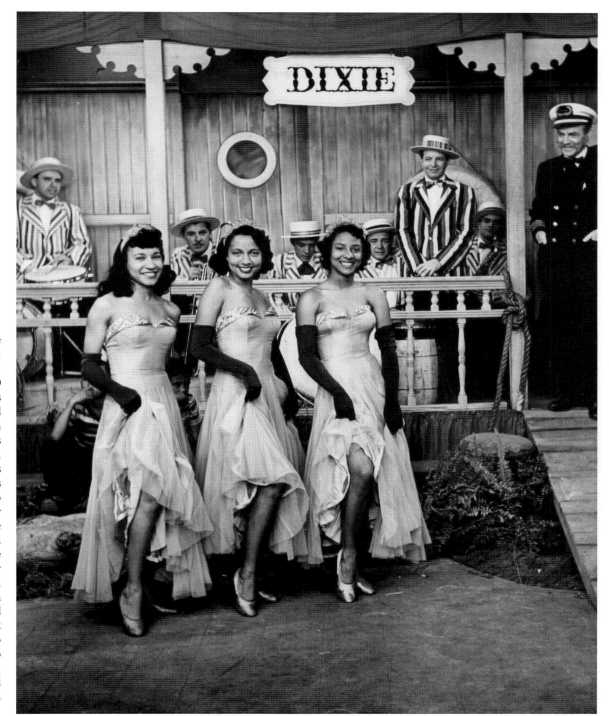

This program led to one of the more bizarre incidents in local television history. *Dixie Showboat* was on at 9:00 p.m. Monday nights, and before that, at 8:00 p.m. on Mondays, was the public affairs show *Teleforum*, hosted by the 75-year-old former president of University of Southern California, the austere, esteemed Dr. Rufus B. von Kleinsmid. On one particular night, Dr. von Kleinsmid had invited two senators to appear on his program. The politicians arrived at the studio and were taken to makeup. The makeup artist thought they were to be on *Dixie Showboat* and made them up in blackface. Having never been on live television before, they assumed the makeup was what they needed for the new medium. Moments before *Teleforum* began, they were ushered into the studio to a horrified Dr. von Kleinsmid. He realized what had happened and rushed them back to makeup. Cold cream was applied to remove the blackface, with seconds to go before airtime. They were quickly seated, but unfortunately, because of the hurried repair job, their ears were still covered in black makeup. (Courtesy of KTLA.)

LOS ANGELES TELEVISION

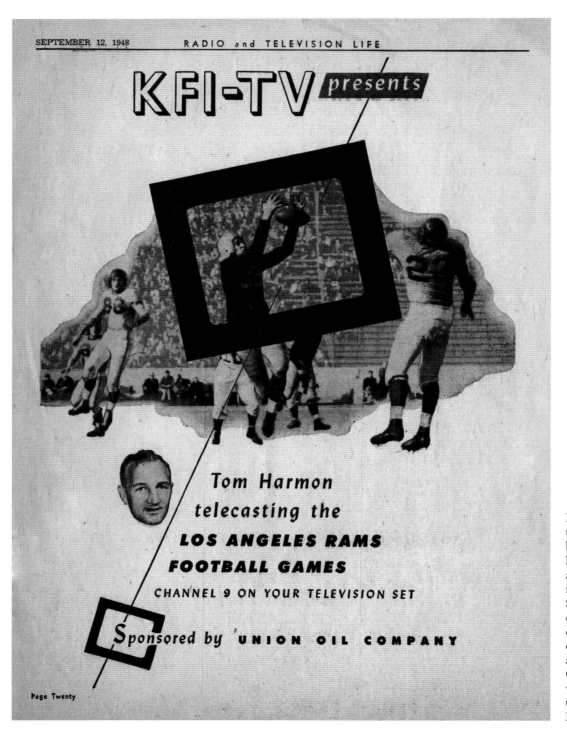

KFI-TV Channel 9 had a short but busy life. It televised lots of sports like Pacific Coast League baseball and Rams football. In 1949, it produced the live weekly series *Treasures of Literature*, produced and directed by Peggy Webber, who also starred in many of the classic adaptations. The budget was $300 a show. The wardrobe was borrowed from costume houses, and the actors received $10 for each program. The station also carried 46 weeks of opera. In 1951, the technical staff voted to join a union. The station's owner, car dealer Earle C. Anthony, said if the union was voted in, he would sell the station. Anthony sold the station to General Tire and Rubber, which also owned KTSL Channel 2. (Courtesy of *TV-Radio Life*.)

THAT'S ENTERTAINMENT

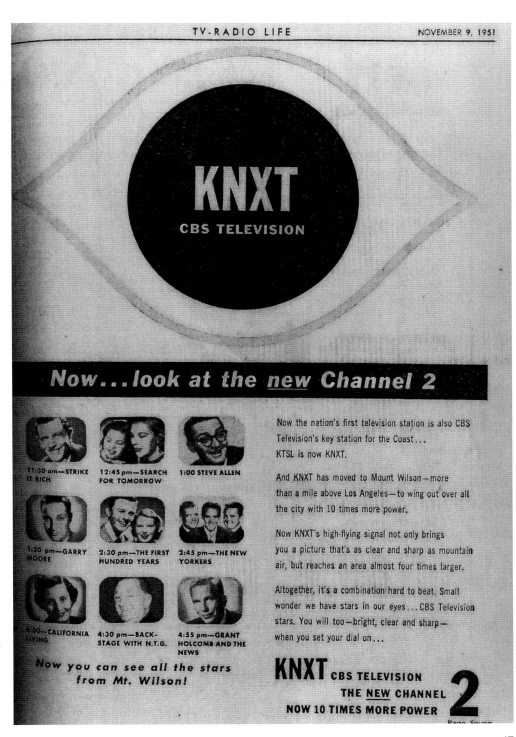

At about the same time, William Paley, the head of CBS, had wanted all the CBS-owned television stations to be on a Channel 2, believing viewers who turned on their sets would always start there. Since 1949, CBS programs had been seen on Channel 11. In a major transaction, Channel 2 was bought by CBS, and KTSL became KNXT. KFI-TV went away and Channel 9 became KHJ-TV. KTTV Channel 11 became an independent station wholly owned by the *Los Angeles Times*. The old Channel 2 transmitter atop Mount Lee was shut down, and KNXT had to build a new one on Mount Wilson. Since KNXT was the last of the seven original stations to build there, it wound up with the worst location and suffered with bad signal strength for many years. Several of the on-air personalities who had been popular on KFI-TV moved over to KNBH, NBC Channel 4. (Courtesy of *TV-Radio Life*.)

On May 19, 1950, KTLA premiered *Ina Ray Hutton and Her All-Girl Orchestra*. Originally, the one-hour weekly musical variety show was just to be a summer replacement for the *Harry Owens Hawaiian* show, but it became so popular it had a regular spot on the schedule that fall and was sponsored by a beer company. Jerry Lawrence, the commercial announcer and only male on the program, would finish each of the live commercials by chugging down a large glass of beer. Because of that and other beer advertisements, the FCC banned alcohol being consumed in a television commercial. That still goes today. Another noteworthy moment came March 1, 1953. In the middle of the show, Hutton announced an important news event had taken place and to stay tuned after her program. The bulletin that was withheld until the show was over was that Russia's Joseph Stalin had suffered a severe stroke. This was enormous news during the Cold War, and Stalin died a few days later. (Courtesy of KTLA.)

Klaus Landsberg loved big band shows and was always good at picking talent for television. One night, he stopped by the Aragon Ballroom on Lick Pier in the Ocean Park area of Santa Monica and saw the crowd eagerly dancing to the music of an accordion-playing bandleader from North Dakota named Lawrence Welk. Welk had a German accent and a swinging band, and Landsberg offered to put him on KTLA Friday nights at 11:00 p.m. for a four-week test. The first broadcast was on May 18, 1951. The results were so good that Welk was signed to a regular contract. The good news was delivered to Welk by announcer Dick Garton just as the last of the test shows was signing off. *The Champagne Music of Lawrence Welk* was moved to 8:00 p.m. Friday nights and became another hit live show. (Courtesy of KTLA.)

Roberta Linn was Welk's "Champagne Lady" who sang on the show. She remembers that because of Welk's accent, every letter *B* sounded like a *P*. When she was introduced by Welk, it would be as "Roperta Linn." According to her, on the first night of the test broadcast, everyone was nervous, as Welk and his band had never been on television before. Just before they went on, Welk turned to the band and announced, "I want you all to 'p' on your toes."

In July 1955, the ABC network gave Welk a one-hour prime-time show, but because of his KTLA contract, the ABC show could not air in Los Angeles until October 1955. Klaus replaced Welk's show with another big band program, *Orrin Tucker and the KTLA Crystal Tone Orchestra*, featuring Roberta Linn, who also had her own show, *Café Continental*. (Courtesy of KTLA.)

THAT'S ENTERTAINMENT

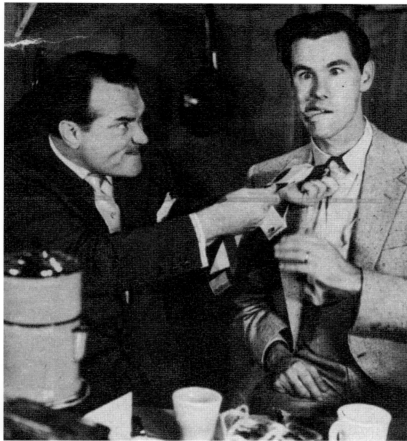

In 1951, a 26-year-old Johnny Carson from Corning, Iowa, walked into the KNXT Channel 2 studios looking for a job. He had hosted a morning television show at WOW-TV in Omaha and had some good references. He was hired as a staff announcer and soon given a five-minute show from 8:55 a.m. to 9:00 a.m. two days a week called *Carson's Coffee Break*. One of his fans was Red Skelton, who offered to appear on the show. When he showed up, Carson put tape over his mouth, saying the show was not long enough for a guest. Skelton kept returning, sometimes just sitting silently in the background. (Both, courtesy of *TV-Radio Life*.)

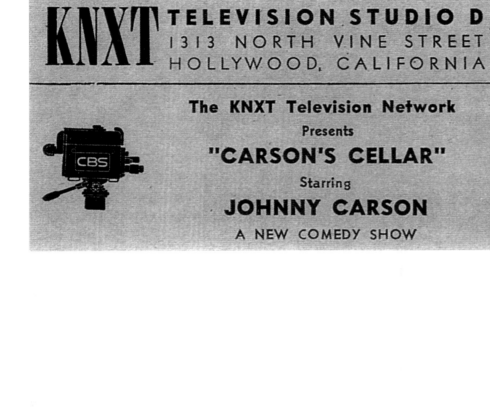

Carson also had a half-hour sketch show on Channel 2 called *Carson's Cellar* and hosted a panel show called *Platter Panel*. In late 1953, Johnny left Channel 2 to become one of Skelton's network writers. One day, Skelton severely injured his back during rehearsal and could not do the show. With just a few hours to prepare, Carson hosted the show that night, and his network career was fast tracked. (Courtesy of *TV-Radio Life*.)

Television history was again made on September 23, 1951, when the first entertainment program was broadcast live from coast to coast. It was a fundraiser for the 1951 Crusade For Freedom Drive and originated in both New York and Hollywood. In all, it was a 12-hour variety show with a half-hour portion originating from Columbia Square. Ed Sullivan hosted from New York. The first actual live coast-to-coast broadcast was the opening of the Japanese Peace Conference in San Francisco a few days earlier, but that was considered a news event.

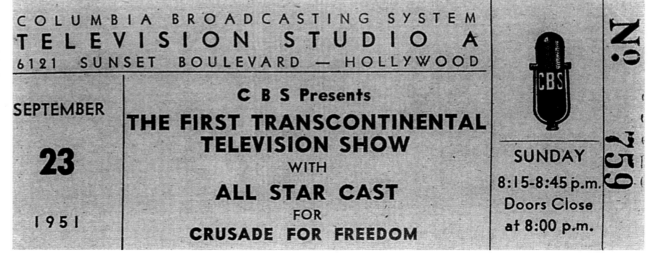

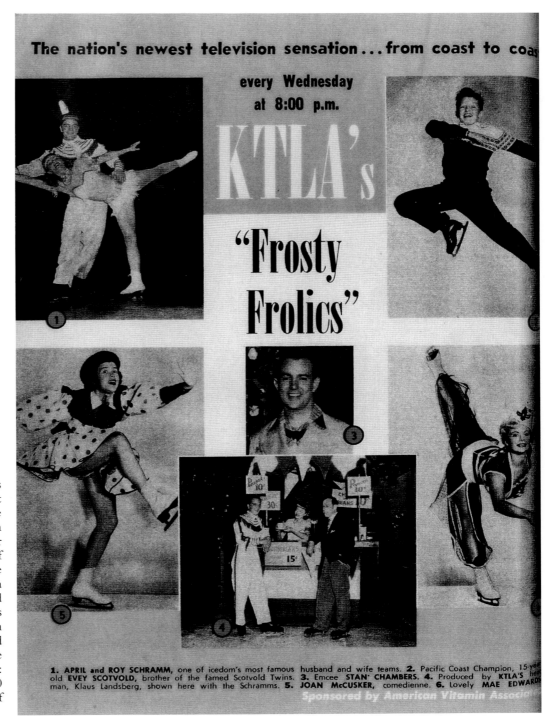

One of Landsberg's most original creations was *Frosty Frolics*, which premiered June 15, 1951. It was a variety show on ice, which supposedly came from the Alpine Hotel but actually broadcast from the Hollywood Polar Palace and then the Winter Gardens in Pasadena. The cast included members of various ice shows, and Stan Chambers was the affable host. People would call the station and want to get a room at the Alpine Hotel. Tickets for the seats around the rink were reserved months in advance. Chambers could not ice skate, so each show would end with the cast dragging him onto the ice, where he would invariably tumble. The ABC network picked up the show, so the cast and crew would do two live shows: one for ABC at 5:00 p.m. and one for KTLA at 8:00 p.m. *Frosty Frolics* ran for two years. (Courtesy of *TV-Radio Life*.)

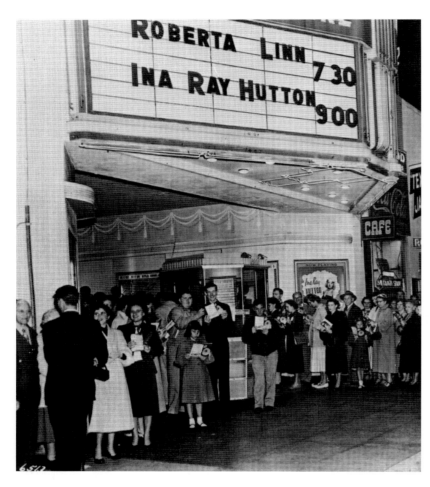

In the early days of television, the most popular shows, both on national and local networks, were variety programs. KTLA's two small studios did not allow for studio audiences; however, the answer for Klaus Landsberg was just across the street. The Melvan Theatre, located at the corner of Melrose and Van Ness Avenues, was just what was needed. The Melvan had mostly shown art and foreign films until KTLA purchased it and renamed it the KTLA Studio Theatre. The control room was built upstairs where the projection booth used to be, and a camera ramp was installed, jutting out a few rows into the seats for long shots of the various productions that would soon be broadcasting from the site. (Courtesy of KTLA.)

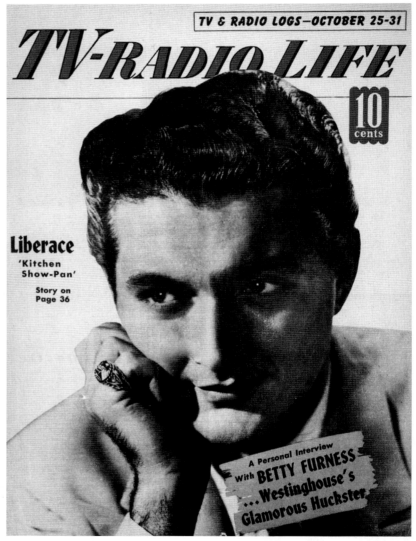

Walter Liberace was a young piano player from Wisconsin who moved to Los Angeles to find fame and fortune. He played supper clubs and had scant attention, but in early 1952, he was playing at the Hotel del Coronado in San Diego when the general manager of KLAC-TV Channel 13 saw him perform. He thought "Lee" might be good on his station, though it was a hard sell to the station's advertising department. However, on February 3, 1952, *The Liberace Show* premiered live from the Music Hall Theatre. The program was unsponsored. The studio audience loved him, and by the next week, he had a sponsor and the fame he was looking for. The next year, he won two Emmys. The show eventually went into syndication, and *The Liberace Show* was a nationwide hit. (Courtesy of *TV-Radio Life*.)

When television first became the next big thing, bar owners were quick to buy sets, as they knew lots of people would drop by to watch sports coverage. Nothing was bigger in the 1940s than wrestling. W6XYZ started televising it in 1946 with Dick Lane and continued it well into the 1960s. Wrestler Gorgeous George, pictured here with Lane, became a giant television star. There was also roller derby, hosted by the ubiquitous Dick Lane from the Olympic Auditorium; Pacific Coast League Baseball's Hollywood Stars with Sam Butler on Channel 13; and the Los Angeles Angels on Channel 9 with Bill Brundage and Lyle Bond. There was boxing from the Hollywood Legion Stadium with Hank Weaver on Channel 7, and so-called "trash" sports like moto-polo, destruction derby, and donkey baseball. (Courtesy of KTLA.)

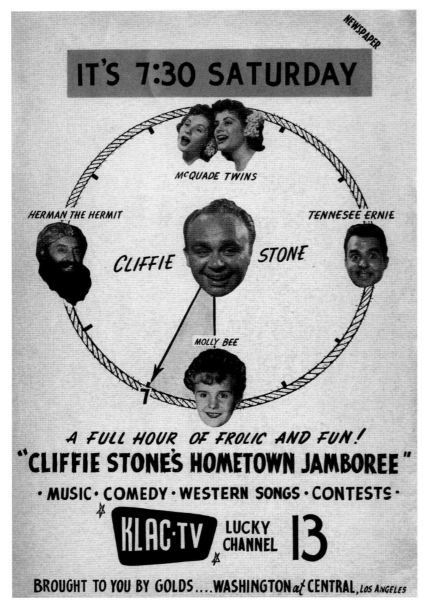

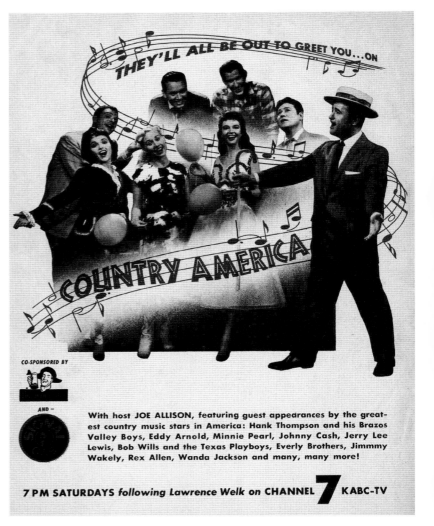

Channel 7 had *Country America*, and Channel 11 had *Town Hall Party* with Jay Stewart, Tex Ritter, and Merle Travis. *Tex Williams* was on Channel 4, Jimmy Wakely was on Channel 2, Ken Curtis and the Sons of the Pioneers were on *Lucky U* on Channel 9, and Doye O'Dell had *Western Varieties* on Channel 5. (Courtesy of *TV-Radio Life*.)

After World War II ended, lots of folks moved to the Los Angeles area, and many of them loved country and western music. Local television obliged, and each station had its own version of a country-western show. *Hometown Jamboree* started on KLAC-TV Channel 13 in 1950 and starred Cliffie Stone, Molly Bee, Tommy Sands, and Tennessee Ernie Ford. Stone remembers the first broadcasts: "We served a purpose. They learned about cameras, about light and sound, about production." (Courtesy of *TV Time*.)

A staple of local television in the 1950s was the daytime cooking show, and the chefs on these shows became stars. Channel 4 had Mike Roy (above, left), Channel 7 featured Chef Milani (above center), and Channel 9 had Mama Weiss with Eddie Coontz (above, right). (All, courtesy of *TV-Radio Life*.)

Channel 5's entry into daytime cooking shows was *Tricks and Treats* with Corris Guy. She was always assisted by Stan Chambers, who bravely tasted the food. (Courtesy of KTLA.)

Monty Margetts cooked on both Channel 9 and then Channel 4. At KFI-TV, she worked on its single crowded stage, where all the live daytime shows were lined up one after the other. As one show ended, the cameras and boom mics quickly moved from one set to the next during the short station breaks. *The Bill Welsh Show* was ending as Monty was finishing cake batter, her first recipe of the day. As the cameras came charging her way, a lighting technician took a tall pole and adjusted one of the hanging lights above her. As he did, black paint chips dropped from the light into her batter. Horrified, she screamed, "What am I going to do?" Calmly, the technician replied, "That's alright, just tell them they're raisins." (Courtesy of *Televiews*.)

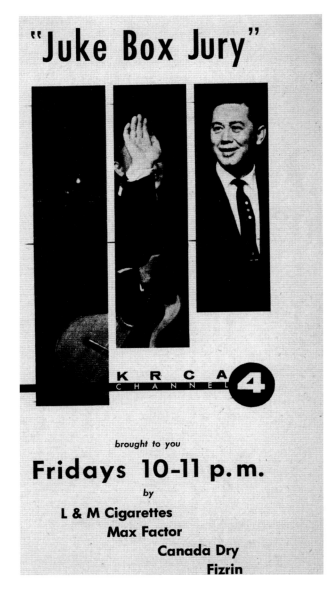

Peter Potter (whose real name is William Moore) was a Los Angeles radio disc jockey who came to KNXT Channel 2 with a program he called *Juke Box Jury*. Potter would play new records and have a panel of celebrities rate whether that single would become a hit or a miss. There were four celebrities, so when there was a tie vote, he would turn to the studio audience, which he called "the grand jury," to decide. The program aired on Saturday nights at 11:00 p.m. and was so successful it later went to the ABC network and also to CBS network radio. It eventually moved to Channel 4 and had a long run on BBC-TV in England. (Courtesy of *TV-Radio Life*.)

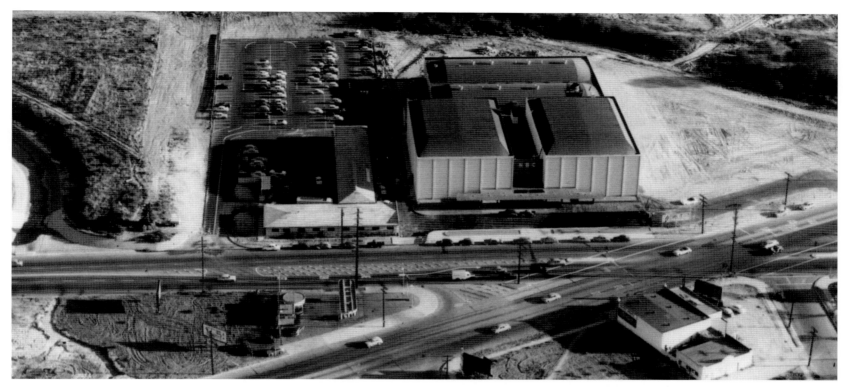

CBS and NBC were both building network studios in Los Angeles as television was moving west. CBS Television City in the Fairfax district was scheduled to open on November 15, 1952, and NBC announced it was opening its Burbank studio on October 4, 1952, with a live coast-to-coast transmission of the *All-Star Revue*. After that date was released, CBS moved its premiere date to October 3, 1952, with the live presentation of *My Friend Irma*, citing it as "the first origination from Television City, the world's first plant designed and built exclusively for television." (Above, courtesy of NBC Universal Archives and Collections.)

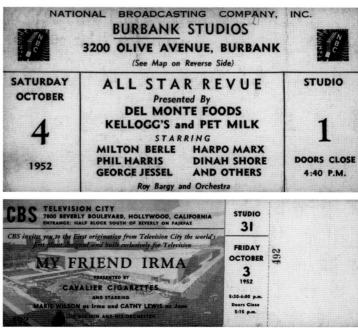

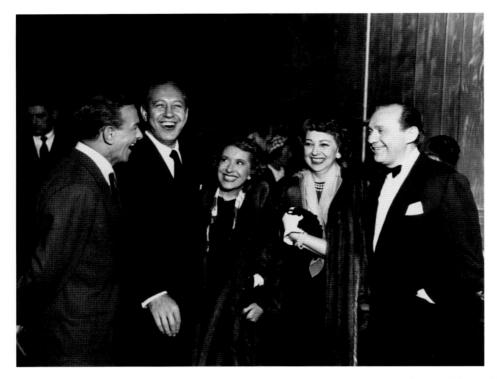

VIPs attend the formal opening of CBS Television City on November 15, 1952. Guests include, from left to right, George Burns, William Paley, Gracie Allen, Mary Livingstone, and Jack Benny. Paley, chairman of CBS, had engineered a huge talent raid in 1949, capturing Jack and Mary Benny, Burns and Allen, Amos n' Andy, and Edgar Bergen and Charlie McCarthy from NBC radio. His lure was to give each of the stars ownership of their radio and television programs. (Courtesy of CBS.)

On November 3, 1953, the media was invited to the first West Coast demonstration of compatible color television. CBS had actually devised a color system first a few years earlier, but since it was not viewable on black and white sets as well, the FCC turned it down and went with the NBC-RCA system. Since only RCA, which owned NBC, made color cameras, CBS was forced to use them. CBS chairman William Paley ordered the RCA logos removed from the cameras before they were installed at CBS.

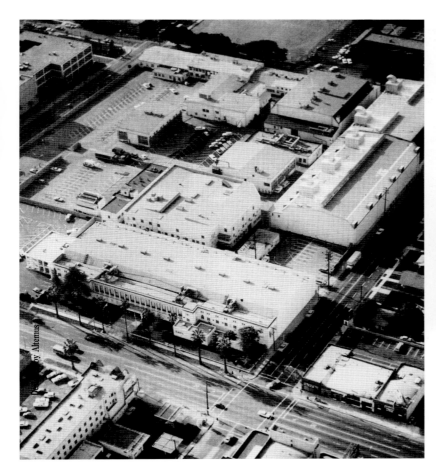

With just two small studios and the Melvan Theatre, KTLA needed more space for its burgeoning schedule of live programs. In 1954, Paramount purchased the first West Coast home of Warner Bros. on Sunset Boulevard. The 10-acre facility would be divided; the east half would be for KTLA, and the west half would be for Paramount and any others wishing to rent the many stages. The KTLA facilities consisted of two audience studios and a third stage just for the many live commercials during the broadcast day; in addition, there were offices, a scenery dock, and engineering space. The Melvan was given up and returned to being a movie theater. During the transition between the old and new KTLA homes, Landsberg hastily drove the few miles to produce and direct from both locations. (Courtesy of KTLA.)

By late 1953, the NBC network had begun limited color broadcasting. Klaus Landsberg wanted KTLA to be the first Los Angeles station to originate programs in color, both from the studio and on remote. By January 1, 1955, he had obtained the equipment and televised the Rose Parade in color. The traditional spot for black and white coverage was at the corner of Orange Grove and Colorado Boulevards. The color truck, however, was a few miles down the parade route. After the black and white airing, Landsberg and announcer Stan Chambers were escorted by the police to the color location, just in time to catch the start. (Courtesy of KTLA.)

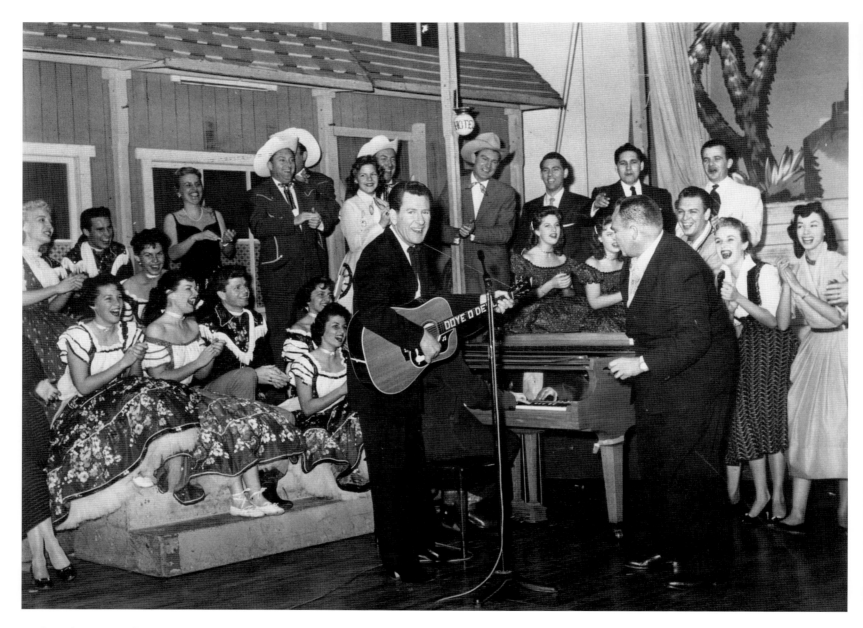

Back at the new Hollywood studios, the color truck would be parked outside one of the audience studios and the country-western program *Western Varieties* would be the first studio show in color. It was hosted by Doye O'Dell (with guitar next to guest Cliffie Stone). One of the show sponsors was Bell Brand potato chips. During live commercials, the advertising agency for Bell Brand was shocked to see that its chips appeared green. The video engineers were following Klaus Landsberg's specific color orders, but the problem was that Landsberg was colorblind. They eventually got it right. (Courtesy of KTLA.)

THAT'S ENTERTAINMENT

Throughout the 1950s, ethnic programming in the form of variety shows was on most stations. One example was *Latin Cruise* with Bobby Ramos and Lita Baron in 1950. (Courtesy of KTLA.)

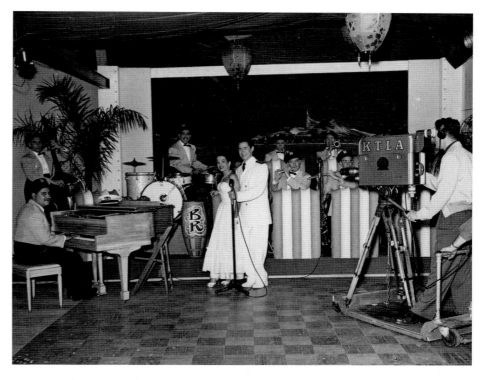

Other local broadcasts were *Harlem Jubilee* on Channel 9 in 1952; Channel 11's *Sepia Spotlight* and *The Tito Guizar Show*, both in 1953; Channel 5's *Latin Carnivale* in 1961; Channel 9's *Leo Carrillo Show* in 1956 and *The Earl Grant Show* in 1958; and Channel 2's *Fandango* in 1955.

On March 27, 1955, NBC telecast a network variety show to herald the opening of its new color studio to Burbank. The plant was called NBC Color City Studios, but the name did not last long.

THAT'S ENTERTAINMENT

One of local television's more bizarre shows was the amateur talent program *Rocket to Stardom*. There were a number of unusual elements to the Channel 11 program. It ran live from 1:00 a.m. to 8:30 a.m. Sunday mornings, as well as Saturdays and Sundays on Channel 9. It originated from Yeakel Brothers Oldsmobile Dealership and was hosted by owner Bob Yeakel. Between amateur acts of all kinds, Yeakel sold Oldsmobiles. On the first night of the show, July 4, 1955, he sold 106 new cars and 50 used ones. There was only one camera, which would move from the performance area to the commercial set. Amateur performers who appeared through the years include the Smothers Brothers, Duane Eddy, Phil Spector, Lenny Bruce, and Poncie Ponce. (Both, courtesy of *TV-Radio Life*.)

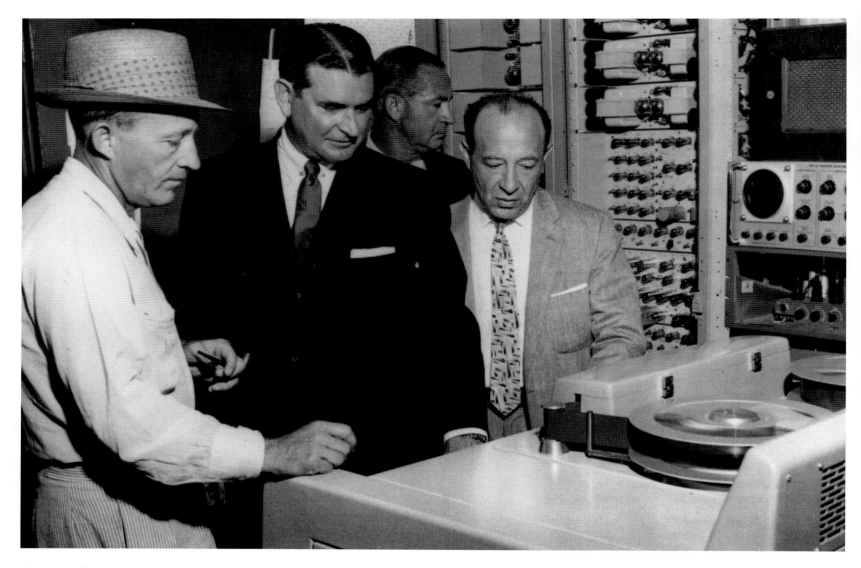

On November 30, 1956, an event took place that changed local and national television forever; the CBS program *Douglas Edwards with the News* was the first program to be broadcast on videotape. The West Coast feed of the show was recorded at CBS Television City and played back three hours later. Ampex invented the VR 1000 to record the playback programs, and each machine cost $45,000. Television City got the first five, and NBC Burbank received the next three. In a few years, all seven of the original stations would get them, and live television, a staple since the experimental days, would take a back seat to taped programs. Early on, editing videotape was awkward. The tape had to be physically cut with a razor blade and patched back together. Bing Crosby, who owned Channel 13 in 1958, takes delivery of the station's first two recorders. Pictured from left to right are Crosby, station manager Kenyon Brown, unidentified, and chief engineer Al Brody. (Courtesy of Ampex Corp./Mitch Waldow.)

By the mid-1950s, the major movie studios realized they could not fight television anymore. They decided to sell their old films to local stations. Channel 2 showcased its newly acquired packages on a Saturday night series called *The Fabulous 52*. Channel 11 bought hundreds of MGM features and ran them on the *Colgate Theatre* Friday nights at 8:00 p.m. That program featured an on-camera host and lots of production to enhance the old films. Channel 9 utilized the RKO library with a groundbreaking schedule; the same movie was shown for one week each night at 9:00 p.m. along with a studio host and lots of trivia called *The Channel 9 Movie Theatre*. The 1954 local Emmy Awards were presented on March 7, 1955. The nominees for Best Entertainment Program were Peter Potter's *Juke Box Jury* on KNXT, *The Lawrence Welk Show* on KTLA, *I Search for Adventure* on KCOP, *Flashback* on KTTV and *The Channel 9 Movie Theatre* on KHJ-TV. The winner was *The Channel 9 Movie Theatre*. A package of vintage feature films beat out four other live broadcasts. (Courtesy of *TV-Radio Life*.)

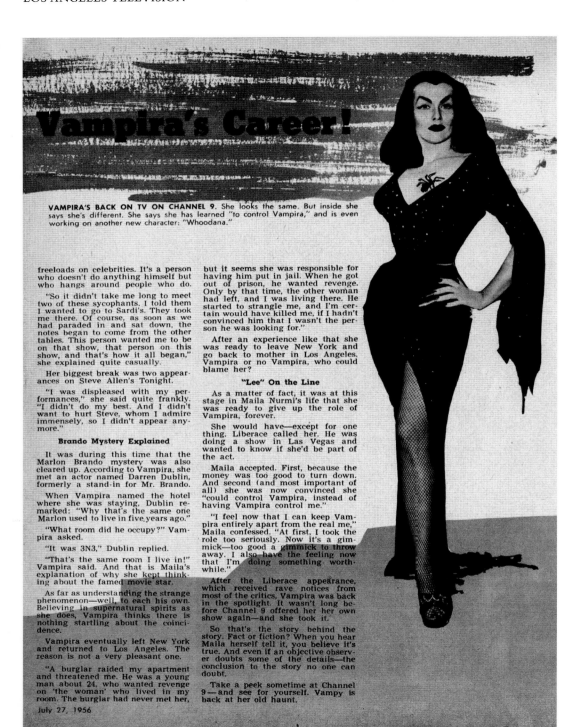

Vampira's Career!

VAMPIRA'S BACK ON TV ON CHANNEL 9. She looks the same. But inside she says she's different. She says she has learned "to control Vampira," and is even working on another new character: "Whoodana."

freeloads on celebrities. It's a person who doesn't do anything himself but who hangs around people who do.

"So it didn't take me long to meet two of these sycophants. I told them I wanted to go to Sardi's. They took me there. Of course, as soon as we had paraded in and sat down, the notes began to come from the other tables. This person wanted me to be on that show, that person on this show, and that's how it all began," she explained quite casually.

Her biggest break was two appearances on Steve Allen's Tonight.

"I was displeased with my performances," she said quite frankly. "I didn't do my best. And I didn't want to hurt Steve, whom I admire immensely, so I didn't appear anymore."

Brando Mystery Explained

It was during this time that the Marlon Brando mystery was also cleared up. According to Vampira, she met an actor named Darren Dublin, formerly a stand-in for Mr. Brando.

When Vampira named the hotel where she was staying, Dublin remarked: "Why that's the same one Marlon used to live in five years ago."

"What room did he occupy?" Vampira asked.

"It was 3N3," Dublin replied.

"That's the same room I live in!" Vampira said. And that is Maila's explanation of why she kept thinking about the famed movie star.

As far as understanding the strange phenomenon—well, to each his own. Believing in supernatural spirits as she does, Vampira thinks there is nothing startling about the coincidence.

Vampira eventually left New York and returned to Los Angeles. The reason is not a very pleasant one.

"A burglar raided my apartment and threatened me. He was a young man about 24, who wanted revenge on 'the woman' who lived in my room. The burglar had never met her,

July 27, 1956

but it seems she was responsible for having him put in jail. When he got out of prison, he wanted revenge. Only by that time, the other woman had left, and I was living there. He started to strangle me, and I'm certain would have killed me, if I hadn't convinced him that I wasn't the person he was looking for."

After an experience like that she was ready to leave New York and go back to mother in Los Angeles. Vampira or no Vampira, who could blame her?

"Lee" On the Line

As a matter of fact, it was at this stage in Maila Nurmi's life that she was ready to give up the role of Vampira, forever.

She would have—except for one thing. Liberace called her. He was doing a show in Las Vegas and wanted to know if she'd be part of the act.

Maila accepted. First, because the money was too good to turn down. And second (and most important of all) she was now convinced she "could control Vampira, instead of having Vampira control me."

"I feel now that I can keep Vampira entirely apart from the real me," Maila confessed. "At first, I took the role too seriously. Now it's a gimmick—too good a gimmick to throw away. I also have the feeling now that I'm doing something worthwhile."

After the Liberace appearance, which received rave notices from most of the critics, Vampira was back in the spotlight. It wasn't long before Channel 9 offered her her own show again—and she took it.

So that's the story behind the story. Fact or fiction? When you hear Maila herself tell it, you believe it's true. And even if an objective observer doubts some of the details—the conclusion to the story no one can doubt.

Take a peek sometime at Channel 9—and see for yourself. Vampy is back at her old haunt.

Probably the most famous movie host was Channel 7's Vampira, created by Maila Nurmi. Each late Saturday night, from April 20, 1954, to April 2, 1955, Vampira would present bad vintage horror movies. The show would open with creepy music, fog, and Vampira slowly walking toward the camera with her pet spider Rollo. Getting close, she would utter a blood-curdling scream and announce, "Screaming relaxes me so." Her show was sponsored by Fletcher Jones Chevrolet. They made a strange couple: she, a sexy vampire, and Fletcher Jones, a straight-laced car salesman. Nurmi reportedly made $75 a week and finally left over a pay dispute. She later turned up on Channel 9. Other strange movie hosts included Voluptua, Gholita, and Elvira. More conventional personalities that hosted films were Bill Leyden, Del Moore, Ed Reimers, and Dick Whittinghill. (Courtesy of *TV-Radio Life*.)

On November 10, 1956, something that had never happened before or since took place. A program was broadcast live at the same time on all seven stations, as well as stations in San Diego, Santa Barbara, and Bakersfield. Except for breaking news, this was a first. The program responsible for making television history was a one-hour Christmas special sponsored by a sofa company. (Courtesy of *TV-Radio Life*.)

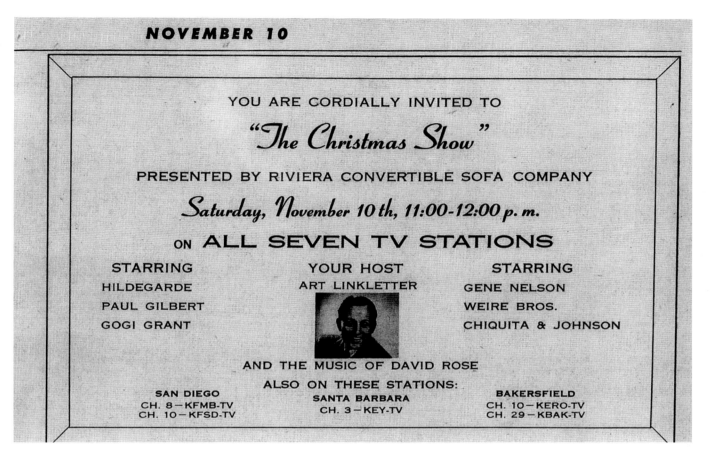

Later in the holiday season, another piece of history occurred: the first television stereo broadcast. It originated from the NBC Burbank studios and featured the Burbank Symphony Orchestra and singer Lucille Norman. The stereo effect was achieved by having the program simulcast on NBC radio affiliate KFI and placing a radio on the opposite side of the room from a television tuned to Channel 4. The audio mix sent separate feeds to radio and television, creating stereo.

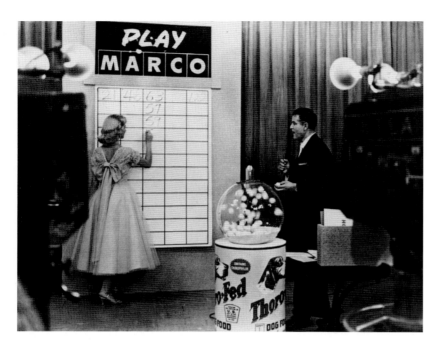

One of the first interactive game shows on local television was *Play Marco* on KTLA in 1955. It was a variation of bingo or today's lotto, and if viewers matched the numbers drawn on their home cards, they called the station (if they could get through). The show has mostly been forgotten, but what folks remember were the commercials. The program was sponsored by Thoro-Fed dog food, and the commercial announcer always ended the live spots by taking a fork and eating the product to show how delicious it was. The show's emcees were Jerry Lawrence and George Sanders, but they did not do the commercials. (Courtesy of KTLA.)

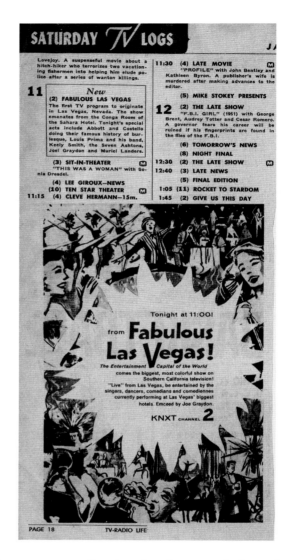

When videotape came to Los Angeles, the network shows finally looked and sounded as good as the live shows, but local stations were still looking to innovate. Channel 2 planned a monthly live variety series originating for the first time from Las Vegas. Even though satellite transmission was still years away, a station could get a live picture from Vegas to Los Angeles with microwave dishes and telephone lines. On January 5, 1957, the first *Fabulous Las Vegas* went on the air. The first broadcast went perfectly, and the next edition was scheduled for a month later. A few minutes before the live 11:00 p.m. broadcast from the Conga Room at the Sahara Hotel, a severe desert windstorm blew over all the transmission equipment, forcing the show to be cancelled. The performers and technicians went home. *Fabulous Las Vegas* never did return. (Courtesy of *TV-Radio Life*.)

THAT'S ENTERTAINMENT

Two of the most volatile personalities on Los Angeles television were Tom Duggan and Joe Pyne. Duggan arrived from Chicago in 1956 to host a talk show on Channel 4. He was opinionated, sarcastic, and telegenic. In 1963, he came to Channel 5 to participate in heated discussions with Bill Stout. Duggan always sat on the right, Stout on the left. Duggan was killed by a drunk driver when he was 53 years old. (Courtesy of KTLA.)

Joe Pyne started in radio in Delaware. In 1964, he was hired by Channel 11 to host a Saturday night talk show with a vocal studio audience. During the 1965 Watts Riots, he held his gun up to the camera and was suspended for a week. His insult to guests was "Go gargle with razor blades." A longtime smoker, Pyne died of lung cancer at 45. (Courtesy of *TV-Radio Life*.)

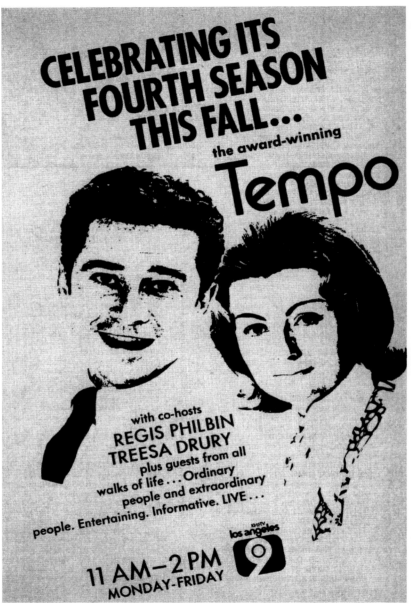

Jeron Konig became one of Channel 13's personalities in the early 1950s. Using his middle name, he became the star of *Criswell Predicts*. Originally, he had bought time on the station to advertise his Criswell Family Vitamins, but between pitches, during the 15-minute show, he began making mostly outrageous, inaccurate, and funny looks into the future. He would enter clad in a tuxedo with "Pomp and Circumstance" playing. Later, he became a regular predictor with Johnny Carson.

Regis Philbin started at Channel 13 as a stagehand in 1957. Soon, he was helping out in the news department. By 1966, Philbin was cohosting *Tempo* on Channel 9 and, later, *AM Los Angeles* on Channel 7.

Local travel shows were everywhere in the 1950s, and Channel 13 had a lot of them. Jack Douglas (left) ran *I Search for Adventure*. Bill Burrud (top right) hosted *Wanderlust*, and Channel 4 had Slim Barnard (bottom right) and *The Happy Wanderer*. One could catch *Global Zobel*, *The Linkers*, *Open Road*, *Vagabond*, *Golden Voyage*, and *Wonders of the World*. Guenther Less was a travel agent who sold Channel 5 a daytime travel show. He would get free films from tourist bureaus and then bring in an expert to talk about them as they both sat around a table. Not necessarily skilled in television, when Less got the cue that time was up, he would kick the guest under the table in the shins to let them know to stop talking. (Courtesy of *TV-Radio Life*.)

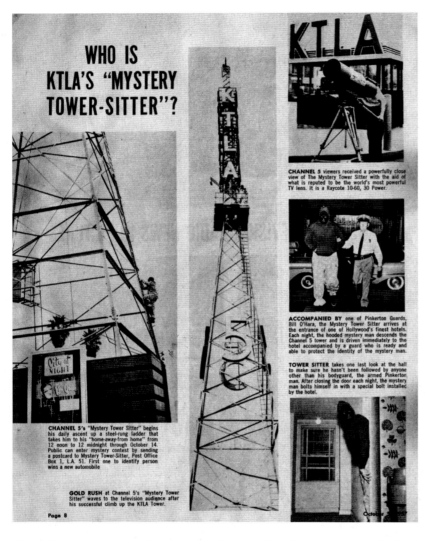
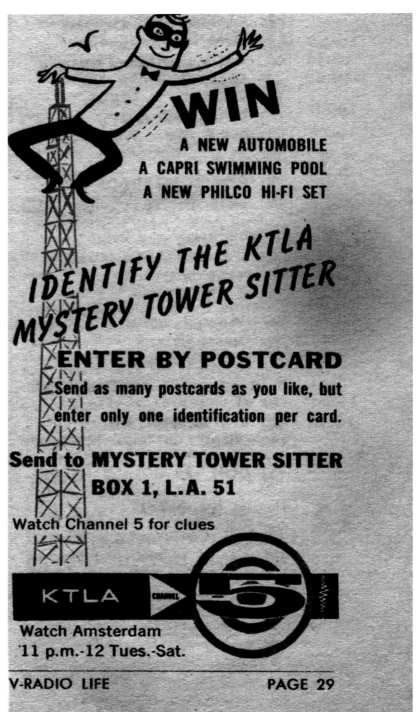

One of the more unusual promotional stunts for a local station took place in October 1957: KTLA's Mystery Tower Sitter. A personality spent from noon to midnight for a week atop a perch on the landmark KTLA Tower. He was disguised, and clues to his identity were given each day on the air. The contestant that guessed his identity correctly won a new car; however, the clues were obscure, and no one won. The mystery tower sitter was six-foot-five-inch-tall B-Western actor Glenn Strange, whose most famous role was as bartender Sam Noonan on *Gunsmoke*. Contestants were not pleased. (Both, courtesy of *TV-Radio Life*.)

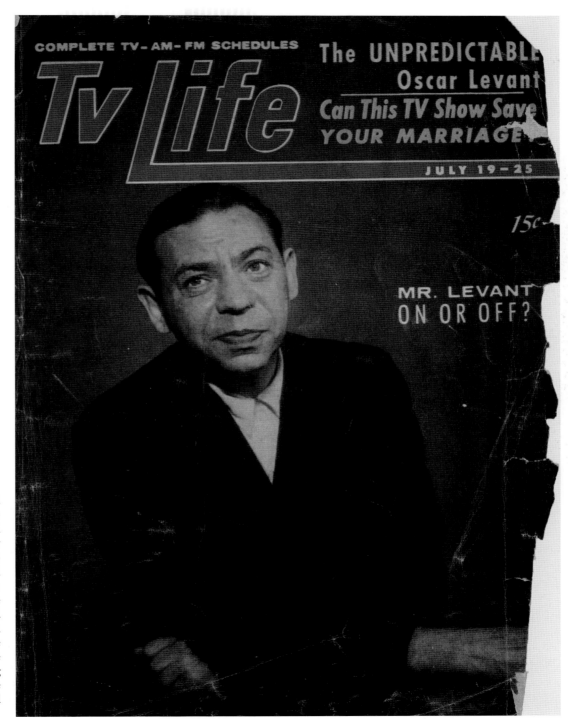

Oscar Levant was an eccentric, acerbic classical pianist, composer, movie star, and radio personality with a razor wit. In 1958, Channel 13 decided to give him his own live talk show cohosted by his patient wife, June. Oscar was also addicted to pills and a hypochondriac, and all of it made for a dangerously entertaining show. There were no seven-second delays in those days, and his comments once had him suspended from the air because the station thought them in poor taste. On the plus side, his show gave the legendary performer Fred Astaire his only live appearance on local television when he sang while Oscar accompanied him on the piano. The show eventually moved to Channel 9 and lasted until 1960. (Courtesy of *TV-Radio Life*.)

Local programs about health were rare, perhaps due to the fact that so many programs were sponsored by cigarette companies. One of the first shows to talk about fitness in an entertaining way was hosted by health guru Jack LaLanne. Starting in 1956, he appeared every morning on Channel 11 in his jumpsuit (and with his dog) to guide viewers through a half-hour workout. All the while, an organist provided appropriate music for the one-camera live show. In the early 1960s, the show moved to Channel 5, where its lead-in was *Yoga for Health*. Other health shows included *Medix* on Channel 2 with hosts Mario Machado and Stephanie Edwards and *Feeling Fine* with Dr. Art Ulene on Channel 4.

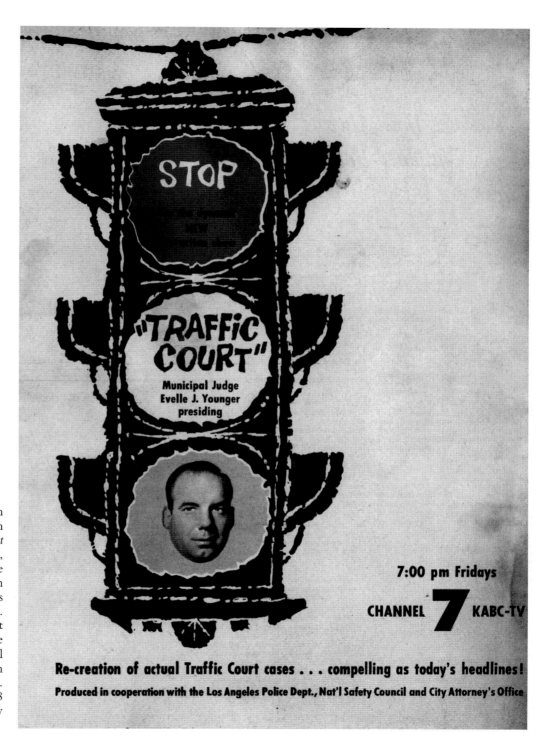

Court shows are now a regular part of the television schedule. The format got its start in Los Angeles on June 7, 1957. That was the premiere date of *Traffic Court* on KABC-TV Channel 7. It was live and ad-libbed, and the defendants were actors who were given just the facts of their case. Four cases were presented on each week's episode and based on actual traffic court cases such as reckless driving, drunk driving, and jaywalking. The cases were heard by Los Angeles Municipal Court judge Evelle J. Younger. He decided the cases on the performances of the actors. Real medical and legal experts, as well as city attorneys, also appeared. An actual marshal and chief clerk were part of the cast. *Traffic Court* had an ABC network run from June 1958 to March 1959 as well as the local broadcast. (Courtesy of *TV-Radio Life*.)

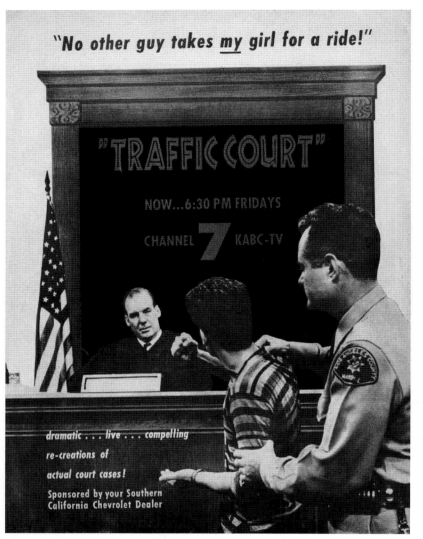

Traffic Court is important in the history of Los Angeles television because its success unleashed a spate of not only court-based reality shows but also documentary-style dramas broadcast from Hollywood. Soon the airwaves were full of similar shows, such as *Divorce Court, Municipal Court, Youth Court, Night Court,* and then *Secret Jury, Police Station,* and *Emergency Ward.* Originally, most were done live, but they were later filmed or taped for syndication. *Day in Court* and *Morning Court* were spinoffs of *Traffic Court* on the ABC network, as was *The Verdict Is Yours* on CBS. (Courtesy of *TV-Radio Life.*)

Religious television programs today are time-buys, paid for by the various denominations. In the 1950s and 1960s, stations donated their time and facilities to present a spectrum of viewpoints. Channel 2 had the *Campus Christian Hour* and *Give Us This Day*, Channel 4 had *Sunset Service, Faith of Our Children* hosted by Eleanor Powell, and *My Favorite Sermon*, Channel 5 offered *In God We Trust*, Channel 9's religious show was *Church in the Home*, and Channel 11's weekly remote was *Great Churches of the Golden West*.

By 1960, big-time network radio was dead, leaving lots of room available at Columbia Square in Hollywood. It had served as home for hundreds of radio programs since it was built in 1938. KNXT Channel 2 moved from the station it was sharing with Channel 9 at 1313 Vine Street to Columbia Square Studios B and C. Studio A would be used by Columbia Records. (Courtesy of CBS.)

In another change, Channel 9 moved to 5515 Melrose Avenue, the building that originally was the first home of NBC network radio in the 1930s.

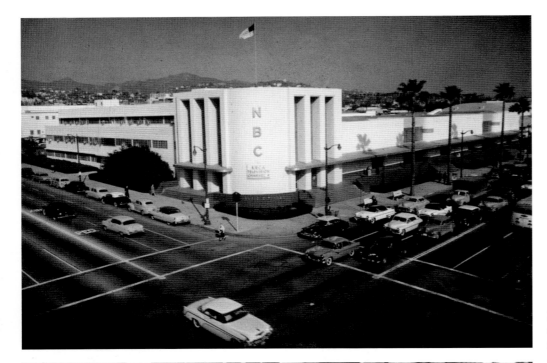

In November 1962, Channel 4 left its original home at the corner of Sunset and Vine and moved into the network's facility in Burbank. In 1965, the beautiful Art Deco Radio City, which had stood since 1938 and was home to thousands of iconic radio and early television programs, was torn down to be replaced by a bank. (Below, courtesy of Los Angeles Public Library.)

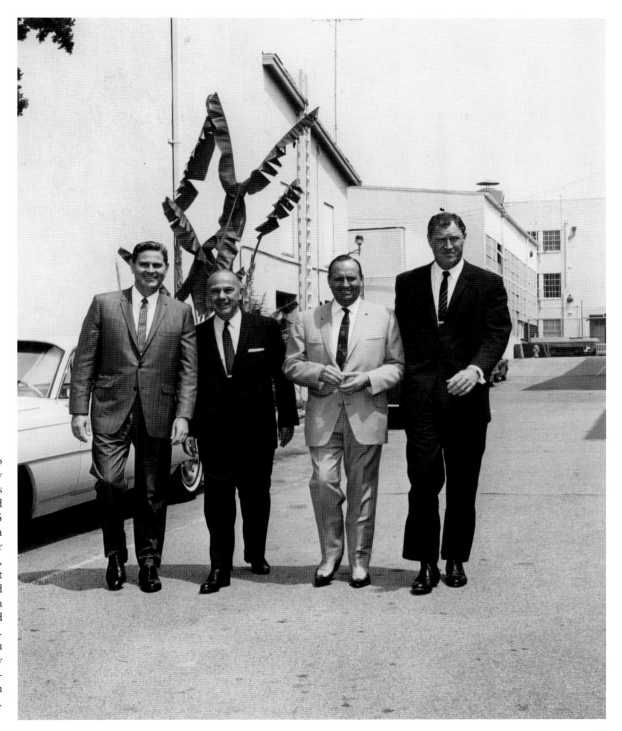

In 1964, cowboy movie star and radio and television station owner Gene Autry bought KTLA from Paramount Pictures for $12 million. In 1983, Autry sold KTLA to an investment firm for $245 million, and a few years later, the firm sold it to Tribune Broadcasting for $500 million. Touring the property are, from left to right, station manager Art Mortensen, Lloyd Sigmon (who created the traffic congestion alert system Sigalert, named after him), Autry, and Bob Reynolds, another Autry partner. One of the first programs Autry put on KTLA was the country music variety show *Melody Ranch*, based on his long-running CBS radio program. Both shows starred Autry hosting and singing. (Courtesy of KTLA.)

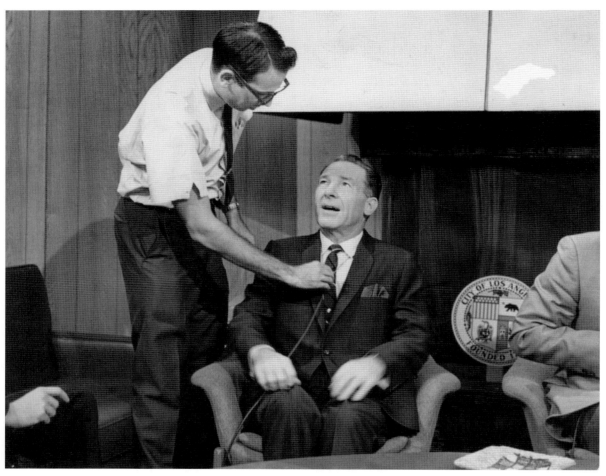

In 1967, Los Angeles mayor Sam Yorty had his own weekly television show on Channel 9 while in office and afterward on Channel 13. He interviewed guests, took questions from the audience, and was referred to in the show's opening as "the internationally known mayor of Los Angeles." It was not the first time politicians gravitated to television in Los Angeles. In 1952, Channel 4 featured a program called *Government at Work*, which featured an orchestra and Los Angeles County personalities. (Left, courtesy of KTLA.)

Ralph Story began his career in Los Angeles radio on KNX in 1948. In 1961, he became part of *The Big News* on Channel 2 with a nightly segment called "The Human Predicament." By 1964, his segment had evolved into a weekly half-hour magazine show called *Ralph Story's Los Angeles*. It was the first show to focus on the city, and it ran successfully until 1970. Story eventually moved to Channel 7 to cohost *AM Los Angeles* with Stephanie Edwards.

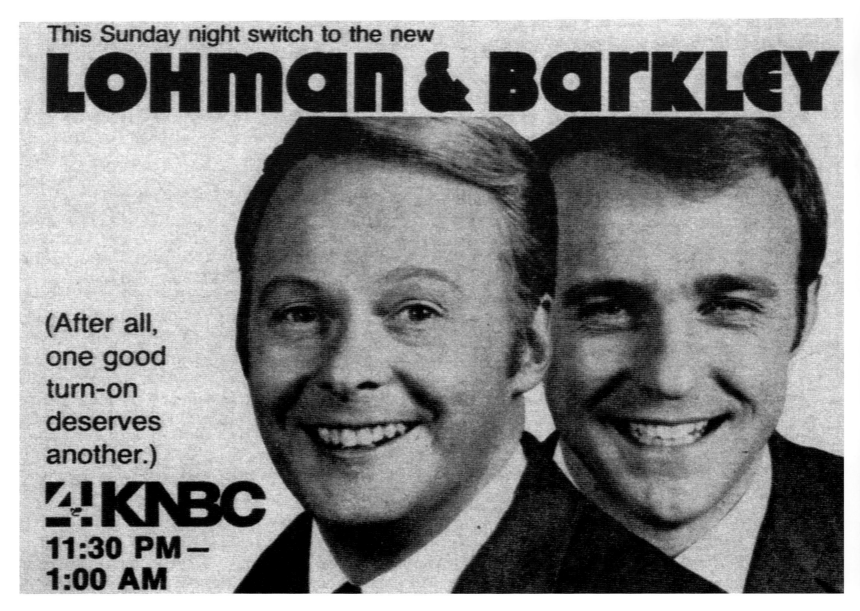

One of the last full-fledged local variety shows took place in 1971. It was the 90-minute weekly *The Lohman and Barkley Show* on Channel 4. Al Lohman and Roger Barkley were a radio comedy team who were morning hosts on both KLAC and KFI radio. KNBC was looking for something to run in a weekend late-night slot. There was a house band led by Stan Worth and satirical skits with a stock company of players including John Amos, Craig T. Nelson, Barry Levinson, and McLean Stevenson.

THAT'S ENTERTAINMENT

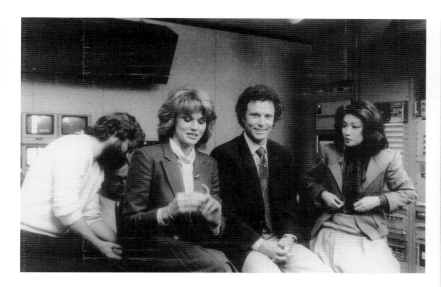

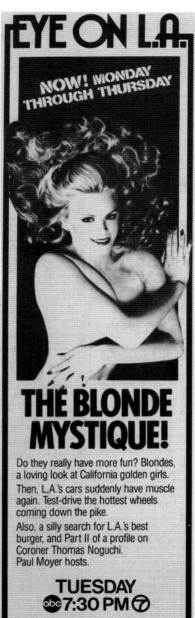

In October 1978, KNXT Channel 2 green-lighted a weekly half-hour local magazine show, *2 on the Town*. It was a shot with a minicam on videotape and was hosted by two of the station's personalities, Connie Chung and Steve Edwards. Chung was a news anchor, and Edwards hosted a daytime talk show and was a weathercaster on the news. In 1980, it expanded to five nights a week, and Melody Rogers replaced Chung. Soon, KABC-TV Channel 7 started its own nightly magazine, *Eye on L.A.*, hosted by Chuck Henry, Tawny Little, Paul Moyer, Inez Pedroza, and Mary Hart, among others. The two magazine shows ran from 7:30 p.m. to 8:00 p.m., and the competition was fierce, with one or the other winning the time slot depending on their programs' content that night and their titillating print and video advertisements. (Above, courtesy of KCBS.)

85

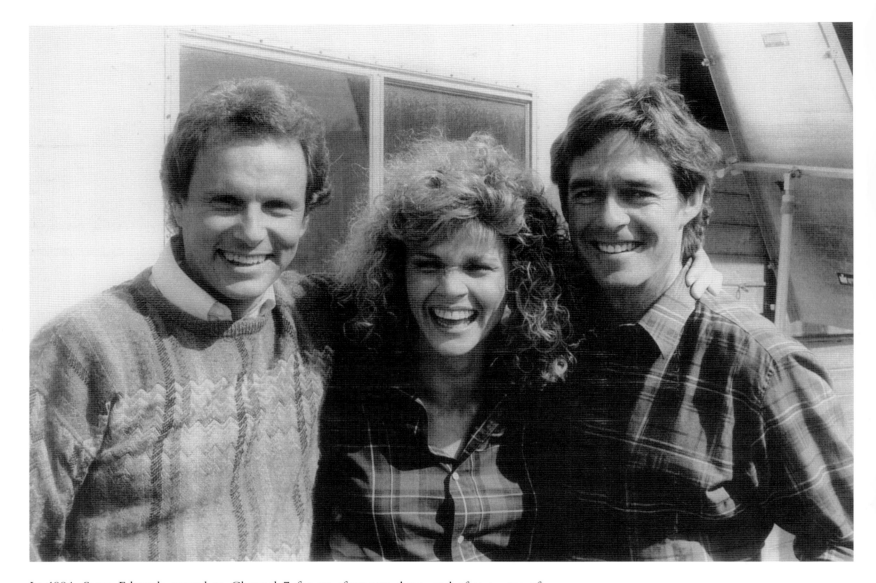

In 1984, Steve Edwards moved to Channel 7 for an afternoon show, and after a year of rotating cohosts on *2 on the Town*, Melody Rogers was joined by ex-Raiders football star Bob Chandler.

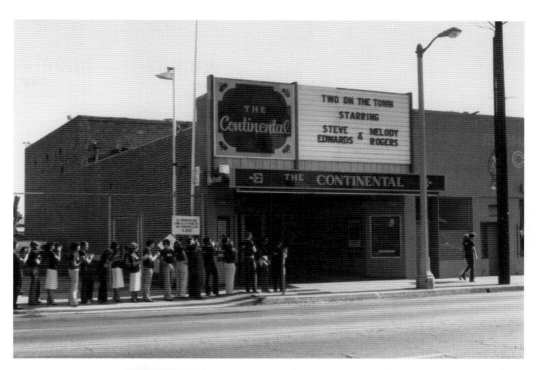

In 1980, when Channel 2's magazine *2 on the Town* expanded to five nights a week, the new staff gathered for a publicity picture in front of the Continental Theatre, which, 30 years earlier, had been the KTLA Studio Theatre, home to so many groundbreaking early local television broadcasts. (Below, courtesy of KTLA.)

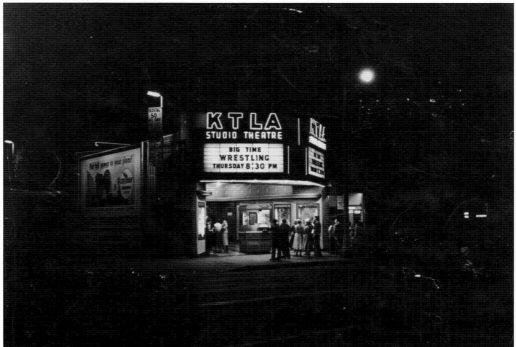

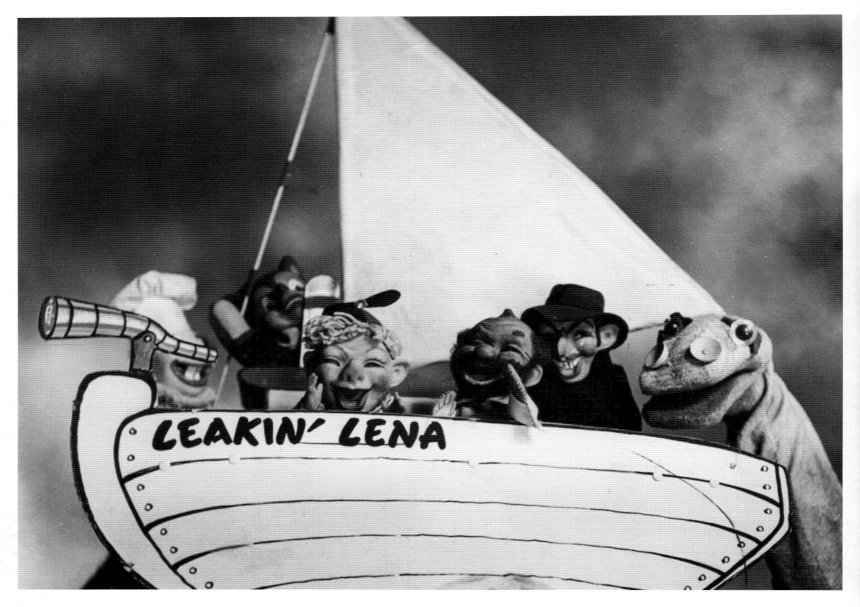

The main characters of *Time for Beany* pose for a group photograph. The series was the most popular children's program in the history of Los Angeles television. (Courtesy of Bob Clampett Productions.)

OPPOSITE: Pictured is Chucko the Birthday Clown, as portrayed by Charles Runyon. His program of the same name ran on Channel 7 from 1955 to 1963 and on Channel 11 from 1963 to 1964. Chucko would sign his autograph, "May all your days be as happy as birthdays." (Courtesy of *TV-Radio Life*.)

THREE
NOT FOR KIDS ONLY

In the early days of television, the formula was simple: get kids to watch television, and parents would come to watch also. *Howdy Doody* was one of NBC network's first smash shows. In Los Angeles, shows for young people became a high priority for all the stations. Not only could they sell products to mom and dad, but they also were also responsible for the purchase of lots of receivers. A family could not watch the neighbors' television indefinitely.

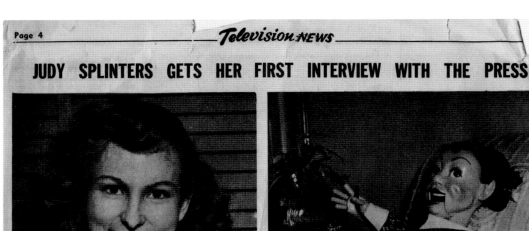

As a young child, Shirley Dinsdale was badly burned in an accident at her home. To help her recover, her father bought her a ventriloquist's dummy. Shirley became quite adept as a performer, and when the family moved to Hollywood, she eventually got a job on the Eddie Cantor's radio program. A ventriloquist on the radio may sound odd, but Edgar Bergen and his ventriloquist dummy Charlie McCarthy helped pave the way. Bergen said of Shirley Dinsdale, she's "the best natural ventriloquist I ever saw." Shirley's dummy was named Judy Splinters and sang as well as spoke. On October 13, 1947, Shirley and Judy starred on KTLA's *Kiddie Party*. Shirley was 21 years old. Not long after that, the show was simply renamed *Judy Splinters* and telecast live six nights a week for two years. (Courtesy of *Television News*.)

Two early live children's shows were produced by Bud Stefan for KTLA. One, *Sandy Dreams*, premiered June 12, 1948, and was the West's first scripted show. In it, eight-year-old Sandy dreams of adventures in faraway places. As she drifts off to sleep, she is transported to a dreamland populated by youngsters who perform songs and skits. It was billed as "the children's own children's show" and starred Rose Marie Iannone, Patti Iannone, and Stuffy Singer. *Fantastic Studios, Ink* was about a group of children who start their own movie studio and act as directors, producers, and even janitors as they try to create pictures to appeal to the youth of America. It ran on Channel 5 from June 3, 1950, to June 1952, and among the cast was 10-year-old Jill St. John. (Courtesy of *Televiews*.)

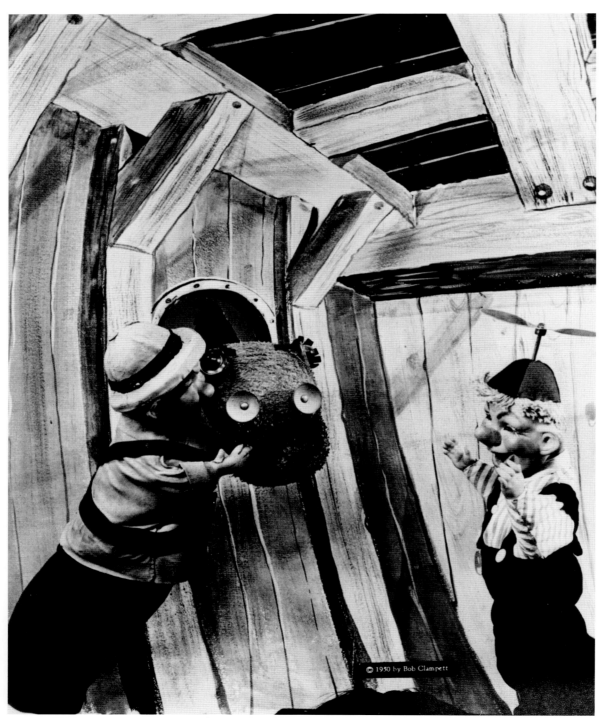

Of all the children's programs on Los Angeles television, the most beloved was probably *Time for Beany*, the puppet show with the voices and puppets controlled by Stan Freberg and Daws Butler. The show revolved around Beany, a little boy with a propeller hat who cruised around on the good ship *Leakin' Lena*, captained by Horatio Huffenpuff. Beany's best friend was Cecil, the world's only seasick sea serpent. The villain was Dishonest John. The show was conceived in the garage of cartoon animator Bob Clampett, who, in 1949, wanted to take his talent to television. He invited Klaus Landsberg to see the garage setup on a Friday afternoon, and on Monday, March 7, 1949, *Time for Beany* took to the air as a 15-minute live show. One of its biggest fans was Albert Einstein, who left a meeting at Cal Tech suddenly saying, "Excuse me, gentleman, but it is time for Beany." The show ran for five years and won three Emmys and a Peabody Award. (Courtesy of Bob Clampett Productions.)

NOT FOR KIDS ONLY

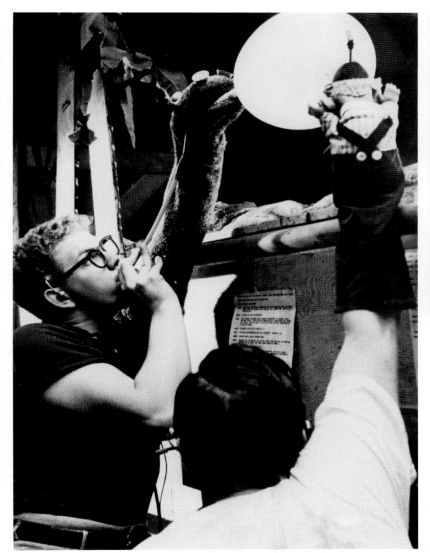

Stan Freberg (left) and Daws Butler voiced the characters as well as worked the puppets. The musical accompaniment was provided by Korla Pandit at the organ. The show was syndicated and later moved to Channel 11. Even later, it became a cartoon show on ABC, broadcasting from 1962 to 1967 and again in 1988. (Both, Bob Clampett Productions.)

Space Patrol on Channel 7 was one of local television's most ambitious programs. Although it was only 15 minutes long, *Space Patrol* was a live five-day-a-week afternoon science fiction series that premiered March 5, 1950. It was so popular in Los Angeles it became an ABC network program on December 30, 1950, and ran until February 26, 1955. The program was set in the 30th century and featured, from left to right (seated) Lynn Osborn as Cadet Happy and Ed Kemmer as Commander Buzz Corry; (standing) Ken Mayer as Robbie Robertson, Virginia Hewitt as Carol, and Nina Bara as Tonga. It was one of the very few television programs that later also became a network radio program.

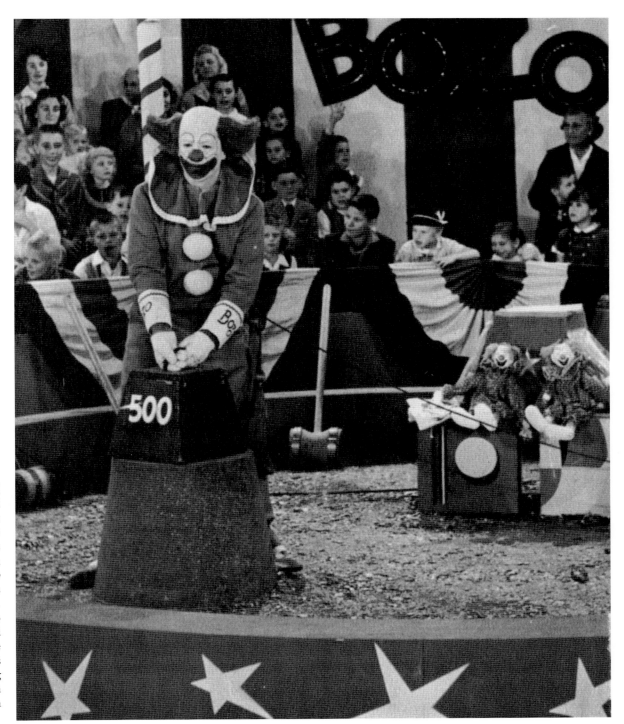

Bozo the Clown started life as a Capitol Records children's recording created by Alan Livingston. The voice was provided by former circus clown Pinto Colvig. Bozo came to Los Angeles television on Channel 11 in 1949 with Colvig. On January 19, 1959, the *Bozo the Clown* show premiered on KTLA as part of its kids' afternoon programming. This time, Bozo was portrayed by Pinto Colvig's son Vance. Games were played with the audience, Bozo cartoons were shown, and lots of children's products were advertised. Earlier, Vance Colvig had portrayed Nutsy the Clown on Channel 4 and Buck Sureshot on Channel 2. (Courtesy of KTLA.)

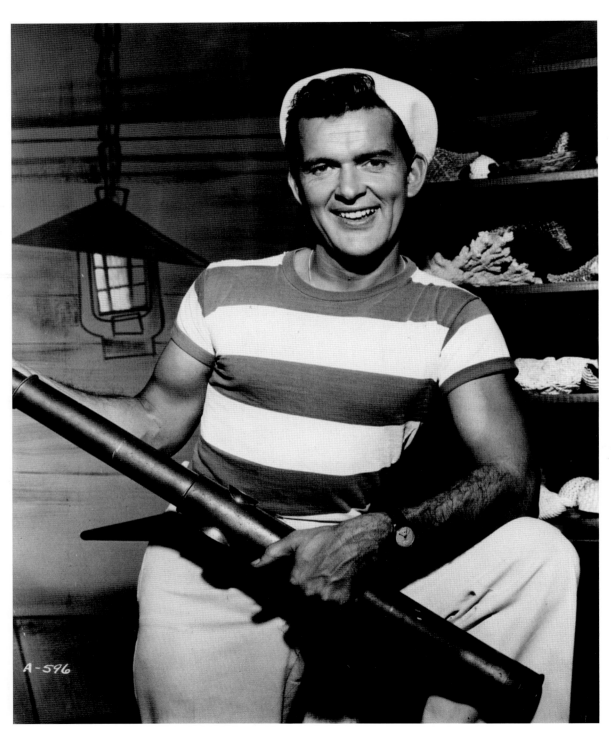

Tom Hatten began at KTLA in 1952 as an off-camera staff announcer, saying things like, "This is KTLA, key station of the Paramount Television Network." Of course, it was the only station of the Paramount Television Network. Finally, Hatten got on camera by filling in for news director Gil Martyn on *Final Edition* and occasionally for Stan Chambers on the *Tricks and Treats* cooking show. His big on-camera break came with a show called *Crash the Party*. Klaus Landsberg's idea was that the show staff would be told about an event going on and then just march in with live cameras with Hatten asking the questions. Hatten would wear a headset into which Landsberg would feed him questions to ask the guests, but the party was so loud, Hatten could not hear the questions. The show lasted four weeks, and then came *The Popeye Show*. (Courtesy of KTLA.)

NOT FOR KIDS ONLY

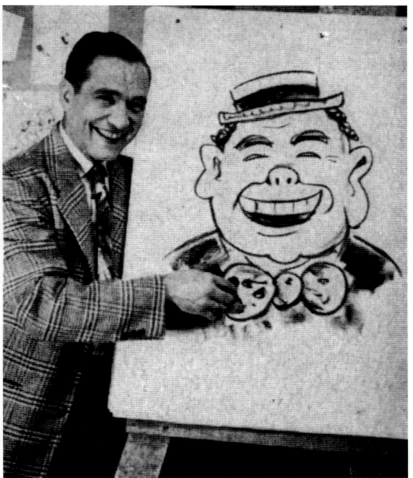

KTLA had bought a package of *The Popeye Show* cartoons and was looking for someone to be the live host, doing the commercials in between the cartoons. Tom Hatten got the job. He had some cartooning experience, so one of the features of the show would have a kid guest draw a squiggle and then have Tom finish it into a cartoon character of some kind. *The Popeye Show* ran each weeknight from 1956 to 1964. When Gene Autry bought the station, all the kids' shows were cancelled. But in 1975, with a new generation of young people watching, *The Popeye Show* with Tom Hatten returned until 1986. In 1980, Tom began hosting the *Family Film Festival*, which ran until 1991. Other cartoonists on local television included "Uncle" Tony O'Dare on Channel 4 (pictured at right) and Frank Webb on Channel 9. (Both, courtesy of KTLA.)

Teenage dance shows were populating the local channels when rock and roll caught fire in the late 1950s and well into the 1960s. Art Laboe was on KTLA in 1957, *Shivaree* aired on Channel 7, and *9th Street West* was on Channel 9 along with *The Real Don Steele*. *Shebang* was a daily afternoon dance show hosted by Casey Kasem (pictured) and was produced by Dick Clark in 1965 on KTLA. (Courtesy of KTLA.)

NOT FOR KIDS ONLY

The Lloyd Thaxton Show aired each weekday afternoon on Channel 13. Thaxton lip-synched to popular recordings, and the teenage audience danced. Thaxton (second from right) is seen here with guest performer Ian Whitcomb in 1966. (Courtesy of Ian Whitcomb/George Sherlock.)

LOS ANGELES TELEVISION

ENGINEER BILL

IN FULL trainman's regalia, Bill Stulla takes Channel 9's Cartoon Express out every weekday at 6:00 p.m. The thrill of railroading, of riding and driving the huge giants, is woven into each telecast, which spotlights a carload of cute cartoons.

The glass of milk Bill holds plays an important part in drawing his young audience into participation. Children in the studio and at home wait with poised glasses for Bill to flash the red and green signals as they drink and pause with an eye on the lights. Anyone who "drinks" a red light is subject to a penalty!

Currently celebrating his 20th year on the air, Stulla has a fling with elders on Parlor Party every weekday afternoon.

By Jean Corlis

Bill Stulla hosted a successful radio show on KFI in the late 1940s called *Ladies Day*. When KFI-TV went on the air in 1948, he moved the show to television. When KFI-TV went off the air in 1951, Stulla moved the show to KNBH Channel 4, and it was renamed *Bill Stulla's Parlor Party*. There was a daily feature called "Castle of Dreams," where children celebrating a birthday walked through the castle door and were given a prize. After KNBH gave up its local time for expanding network programming, *The Bill Stulla Show* moved to KHJ-TV Channel 9 in 1953. Then, on December 20, 1954, Bill Stulla started his march to becoming a local television icon with the premiere of *Cartoon Express*. Stulla dressed as a train engineer with a model train layout in front of him. There, he introduced cartoons, played a milk-drinking challenge with his young guests called "Red Light–Green Light" and featured the train "Little Mo, the Bad Habit Buster." *Cartoon Express* won two local Emmys and ran until 1966. (Courtesy of *TV-Radio Life*.)

Ivy Shinn was born in a small Texas town in 1923. He went on to become a radio disc jockey and changed his name to Jimmy Weldon. He created a partner named Webster Webfoot, a duck, and they became television personalities in Dallas. On September 5, 1952, Weldon and Webster arrived in Los Angeles on Channel 13 and had an afternoon show off and on from then until 1961. (Courtesy of Mitch Waldow.)

Frank Herman had been interested in magic and ventriloquism as a youngster and made his way to Los Angeles for some acting roles. KTLA's *City at Night* was covering one of his performances as Klaus Landsberg was looking for a host for the package of Warner Bros. cartoons the station had bought. The two men met on a Friday afternoon. Landsberg asked Herman what type of character he would like to be to be on air. Herman knew that Paramount owned KTLA, and the Paramount Studios must have had a costume department. That afternoon, he perused the racks of clothes and finally saw a boat captain's uniform and hat. "How about a skipper?" he asked Landsberg over the phone. "I hate it," Landsberg replied, but on Monday, *Skipper Frank's Cartoon Carousel* premiered. It ran from 1956 until 1963. Herman worked with a dummy called Julius. During one telecast, the director noted it was difficult to hear Julius when he spoke. It seemed that a new microphone boom operator would move the mic from Herman to Julius when Julius spoke. (Courtesy of *TV-Radio Life*.)

Local stations seemed to think there was programming magic in finding teenage talent. Lots of amateur performers were featured on various shows. The tickets seen here are *Teen Talent Time* (1949), *Varsity Varieties* (1949), *Talent in High*, one of Bob Barker's first television assignments (1954), *The Gene Norman Campus Club* (1956), *Juvenile Talent Time* (1956), and *Spotlight on Youth* (1959).

The Tim McCoy Show ran on KTLA in 1952. McCoy started acting in silent cowboy films in 1926. He was an expert in Native America lore. He served in the Army Air Corps with the rank of colonel and was always presented as Col. Tim McCoy. His television show for children featured stories of the Old West, and he ran portions of old Westerns. His cohost was a seeming American Indian named Iron Eyes Cody. But after Cody's death, he was found to be Espera de Corti, of Italian descent, born in Louisiana in 1904. As Cody, he appeared in films dating back to the silent era in 1927. However, his most famous role was in a public service campaign for Keep America Beautiful, shedding a tear after trash was thrown from a car at his feet. (Courtesy of KTLA.)

John Rovick was a Los Angeles television icon better known as Sheriff John who hosted two daily kids' shows on KTTV Channel 11. Rovick was a staff announcer at the station. On a Friday afternoon, the program director said they wanted him to host a show featuring the cartoons the station had acquired. The show needed to start Monday, so Rovick went to the Van Nuys Army Navy Surplus Store and looked around for an outfit that would create his television identity. He saw a sheriff's uniform, and that was it. Sheriff John hosted on-air KTTV from July 18, 1952, to July 10, 1970, with *Sheriff John's Lunch Brigade* and *Sheriff John's Cartoon Time*. Each show opened with the sheriff lip-synching a recording of "Laugh and Be Happy and the World Will Laugh With You," then the reciting of the Pledge of Allegiance. Later in the show, viewers' birthdays were celebrated with the birthday song "Put Another Candle on My Birthday Cake." (Courtesy of *TV-Radio Life*.)

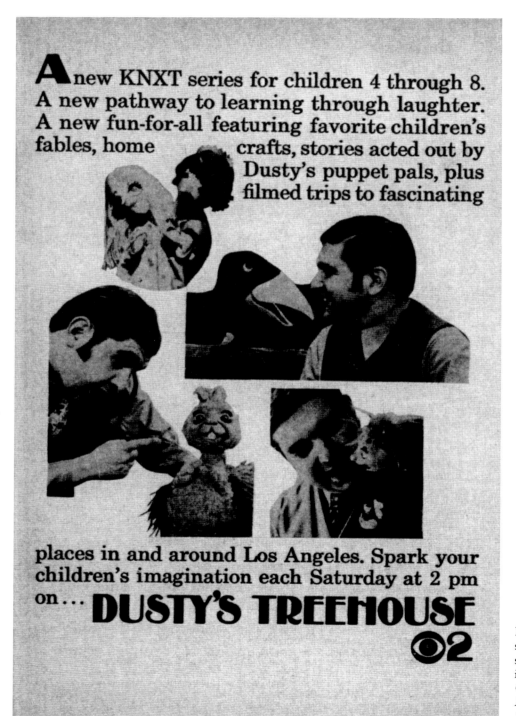

In March 1970, Channel 2 premiered *Dusty's Treehouse* starring Stu Rosen. It was a once-a-week show featuring skits, songs, and demonstrations. It followed more instructional shows through the years such as *Playcrafters Club*, *It's Academic*, *Scholarquiz*, *KidQuiz*, *Agriculture USA*, *Hail the Champ*, *Hobo Kelly*, *Romper Room*, and *The Little Schoolhouse* with Eleanor Hempel.

NOT FOR KIDS ONLY

Serendipity was a weekly Channel 4 show that took young people on field trips around Los Angeles. It ran for three years. In 1973, the program visited newly elected mayor Tom Bradley at his city hall office. The kids were encouraged to ask any questions they had at the places visited. Once, at the largest provider of eggs in the city, one young lady asked the owner where all the male chickens were since only hens were visible. The owner asked the crew to stop filming and explained quietly the males were disposed of since they did not lay eggs. *Serendipity* was produced by Cokie Roberts (pictured in the second row, far left), now of ABC News, and hosted by school principal Rudi Medina (standing beside Roberts). (Courtesy of NBC/Gary Null.)

LOS ANGELES TELEVISION

For the ninth straight year more Southern Californians have watched this man for their news, each weeknight, than anyone else.

There must be a reason.
The Big News 6 pm and Eleven O'Clock Report on CBS●2

The battle for news ratings became fierce between the stations. Channel 2, the perennial leader in the 1960s, pushed hard to keep its dominance as competition grew ugly.

OPPOSITE: Channel 7, the ABC station that billed itself as Eyewitness News, took Channel 2 head on. But Channels 4, 5, 9, 11, and 13 wanted an ever-increasing piece of the money pie also.

Four

The News Wars

News on television in the early days was not a high priority. Promise of local news coverage could help a new station get an FCC license to operate, but the time, energy, staffing, and money mostly went to other kinds of programs. Most news shows were only 15 minutes long, including commercials, and that block would contain five minutes of news, five minutes of sports, and five minutes of weather. Wire service stills were the accepted video, with occasional silent film clips. Rarely seen was film from out of the city or overseas, and the footage would air days late. If one wanted current world news, one could go to the neighborhood movie theater and catch the twice-weekly newsreels. Local news programs certainly were not supposed to turn a profit. That all changed in 1960.

We take issue with channel 2.

We don't question their sincerity.
We question their superlatives.
On February 8, 1970, channel two ran an ad which stated that their news was "the best news broadcast on Los Angeles television."
This is pretty positive advertising.
It doesn't leave much maneuvering room.
Still we believe a little honest competition won't hurt.
And we think that channel two won't mind if we try to make our channel seven news the best news in the world.
(We think it's nicer to aspire.)
Our Eyewitness News comes on live every Monday through Friday afternoon starting at 4:30.
If that's too early for you, watch at 11:00.
We'd welcome your opinions.
Because you're the one who sits in judgement.

We want to bring you the best news in the world.

Eyewitness News 7
4:30 and 11:00 pm
Bonds/Lawrence/Nahan/Sloane KABC-TV

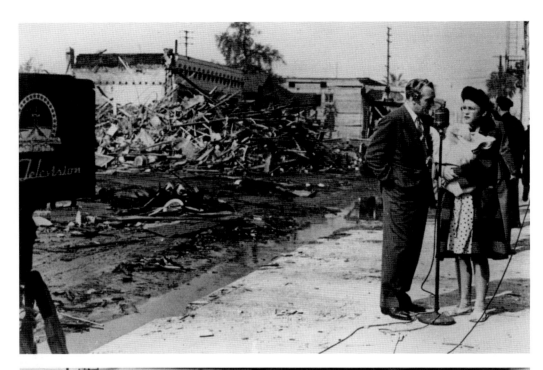
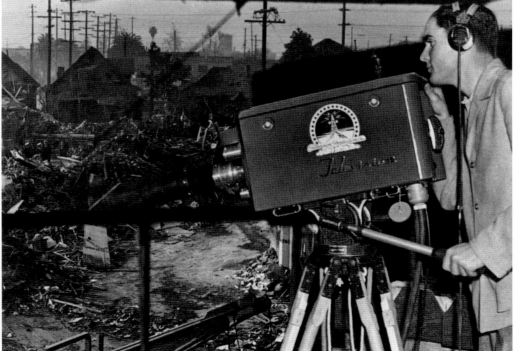

At 9:45 a.m. on Thursday, February 20, 1947, an electroplating plant on East Pico Boulevard exploded, killing 15 people and damaging a mile of downtown Los Angeles. Although it had only been on the air a month, KTLA dispatched live crews and reporter Dick Lane to the scene to cover the event. It was the first breaking news coverage and the very first time television had beaten the city's newspapers to a story. (Both, courtesy of KTLA.)

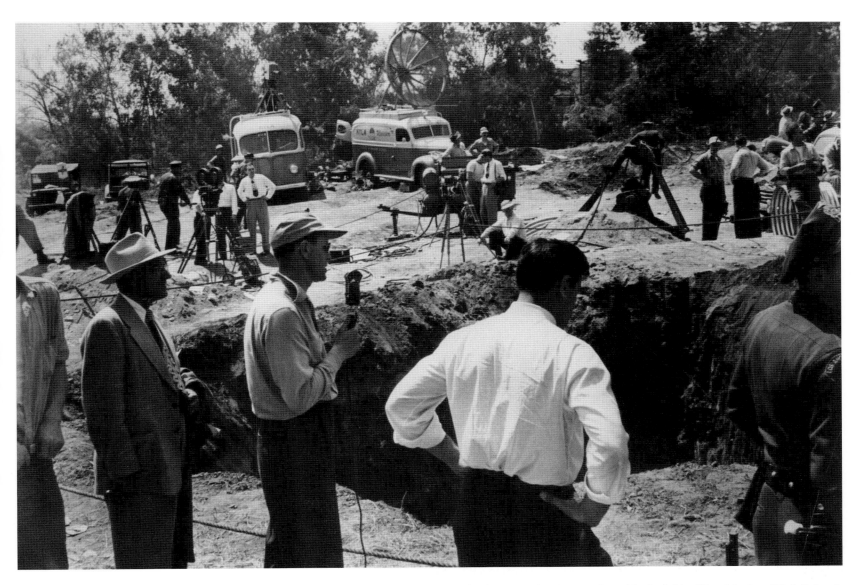

During an event that took place on what is now the athletic field of San Marino High School, Los Angeles viewers hoped as one that a little girl's life could be saved. On April 9, 1949, that field was a vacant lot with an abandoned water well 230 feet deep on it. Three-and-a-half-year-old Kathy Fiscus lived nearby and fell into the well. A massive rescue effort was undertaken. Hearing of the situation, KTLA dispatched its live television equipment and reporters Stan Chambers and Bill Welsh (pictured with the microphone). Its continuous coverage would last 27-and-a-half hours. People who owned television sets invited their neighbors in to watch. Thousands stood in front of an appliance store windows all night. The city came together. For the first time, large numbers of people were able to experience the power of television. (Courtesy of KTLA.)

Unfortunately, the little girl, Kathy Fiscus, was found dead. Stan Chambers (pictured with microphone) remembers, "Rescuers stand silently, heads bowed, unwilling to accept the news. Viewers at home feel the pain of sorrow." The Fiscus family had been watching the coverage in their home but turned off the television after just a few hours. Since the parents had come to know Bill Welsh from the broadcast, the Los Angeles sheriff asked if Welsh could be the one to give the family the tragic news. He put down his microphone and slowly walked into the house. Welsh would later describe the moment, recalling, "I told the family Kathy would not be coming home." (Courtesy of KTLA.)

With today's satellite technology, a live broadcast is available from anywhere in the world immediately. In 1951, Pres. Harry S. Truman had fired popular general Douglas MacArthur for his handling of the still ongoing Korean War. The general returned to the United States, and his first stop was San Francisco. Local stations all rushed to be the first to interview General MacArthur. KTLA news director and anchor Gil Martyn was one of the reporters. (Courtesy of KTLA.)

Gen. Douglas MacArthur had been invited to address a joint session of Congress on April 19, 1951. Television viewers east of the Mississippi could watch the historic event live, but the final link of the coast-to-coast microwave would not be completed until September. Channel 4, KNBH, devised an elaborate system to bring the speech to Los Angeles viewers the same day. The address was filmed off of a television monitor in Washington, DC. Then the undeveloped film was rushed to a nearby airport and put aboard a P-51 racing plane flown by a test pilot traveling across the country to Burbank airport. There, Channel 4 had placed a mobile unit with a film developer inside. As the film came out of the soup, it was rewound, loaded on to a projector, and transmitted to the air—almost breaking news.

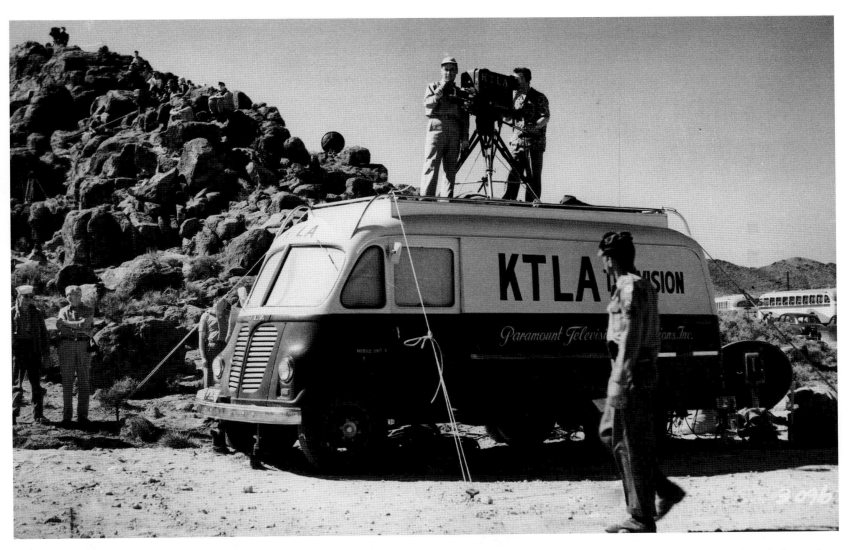

Live television coverage of news events had been taking mostly small steps. That all changed on April 22, 1952. On March 28 of that year, the Atomic Energy Commission approved the first live telecast of an atom bomb test from the Nevada desert, which was also endorsed by President Truman. The three national networks agreed that only KTLA had the equipment and know-how to do the broadcast. The phone company, which normally would provide the lines to feed the picture to the nation, said it would take 12 relay points and many weeks to set up the signal. There were only 18 days before the test. Klaus Landsberg figured KTLA was on its own. On April 4, 1952, the search began for microwave relay points between the Nevada desert site and Los Angeles. Landsberg, wearing a hat, stands atop a remote truck, which was bounded by rope to the ground to protect against the high desert winds. With the help of US Marine helicopters, four relay points were found, including one 140-mile-long relay, the longest television signal ever attempted. (Courtesy of KTLA.)

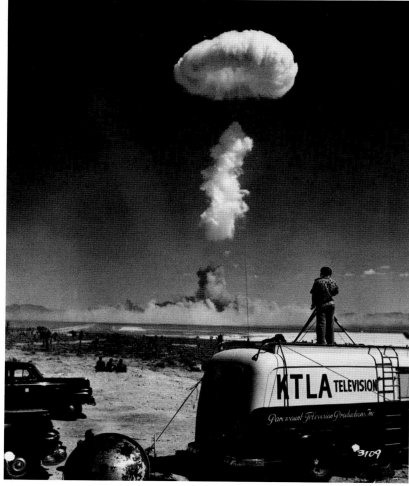

At one location, 12,000 pounds of equipment was installed. Pictured above second from left is Stan Chambers at one of the relay points, with news director Gil Martyn on the right. Fifteen minutes before the scheduled detonation, all power was lost at the main site. It was finally restored seconds before the blast. At exactly 9:30 a.m. on April 22, 1952, the audio and video of an atomic blast was seen and heard across the nation for the very first time. The Atomic Energy Commission reported, "Thanks to the raw courage, physical endurance and technical brilliance of a single individual who, in turn, inspired a great crew of engineers and technicians." (Both, courtesy of KTLA.)

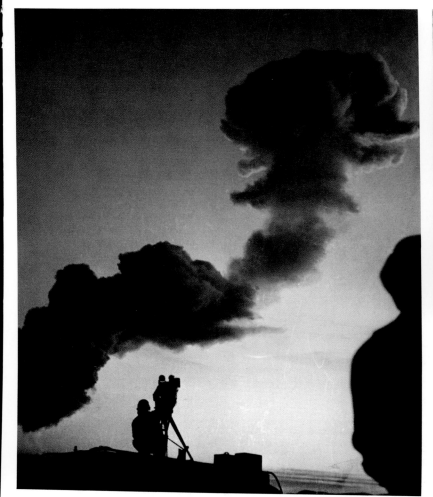
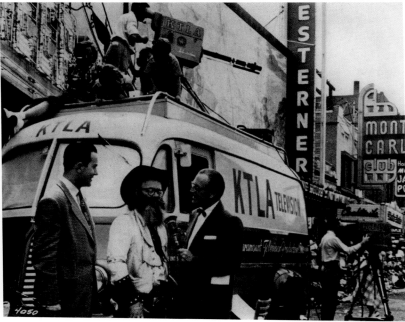

In typical Landsberg style, it was decided that as long as the crews were in Southern Nevada for the atomic bomb, they might as well go down the road and televise the Helldorado Days parade in downtown Las Vegas a few days later. Dick Lane (right) and Stan Chambers (left) interview a parade participant. (Both, courtesy of KTLA.)

During the 1952 Election Night coverage, there was no need to cut away from *The Lawrence Welk Show*. One could listen to the music and watch the vote tally at the same time. However, if viewers wanted to see any of the 1956 Olympics from Australia, they would have to wait a few days while the films were flown to Los Angeles. (Above, courtesy of KTLA; below, courtesy of *TV-Radio Life*.)

In the 1950s, women reporters were rare on local news broadcasts. A shining exception was Channel 2's Ruth Ashton. She reported for that station from 1952 through the 1990s. During the early years of her tenure there, she was assigned "the woman's angle." (Courtesy of *TV Time*.)

Jack Latham was Channel 4's main news anchor from the 1950s through the 1970s. He started at KTLA, and after Channel 4, he went to Channel 11.

One of Los Angeles's most dynamic newscasters was George Putnam. He arrived at Channel 11 in 1951 from New York. He remembers that at first, there was no air-conditioning in the studio, so the station brought in a plane propeller to keep things cool. There was also no regular teleprompter, so Putnam used a toilet paper roll. His two daily 15-minute broadcasts were the highest rated in the early 1950s. The NBC network took notice. In early 1956, NBC was looking for a dual-anchor network newscast with one host in New York and one in Washington, DC. The station heads selected David Brinkley for Washington, DC, and wanted Putnam for New York. Putnam said he would take the job if he could stay in Los Angeles. NBC said no and picked another Los Angeles newsman who would relocate—Channel 7's Chet Huntley. (Both, courtesy of *TV-Radio Life*.)

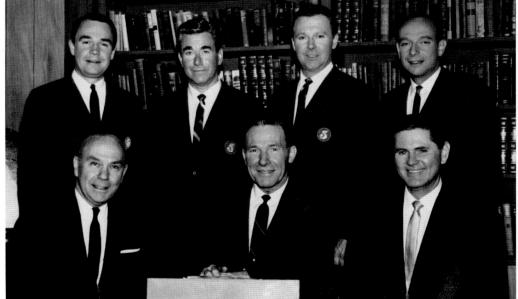

George Putnam's newscasts always featured a salute to the US flag and a commentary called *One Reporter's Opinion*. Most of the time, the commentary was more like "one conservative's opinion." In 1965, Gene Autry hired Putnam to anchor at Channel 5 along with Hal Fishman, who had recently come from Channel 13. Autry insisted all the newsmen wear KTLA blazers. Putnam complained that they made them look like monkeys, and eventually, the blazers were dropped. Reportedly, the character of Ted Baxter on *The Mary Tyler Moore Show* was based 50 percent on Putnam and 50 percent on Jerry Dunphy. Putnam later moved back to Channel 11. Pictured from left to right are (first row) Lloyd Sigmon, Mayor Sam Yorty, and Art Mortensen; (second row) Dick Enberg, Hugh Brundage, George Putnam, and Hal Fishman. (Both, courtesy of KTLA.)

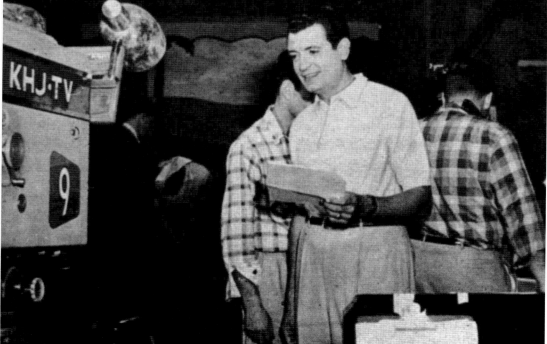

Los Angeles television always had great sports play-by-play announcers. Sam Balter (top left) announced baseball from Gilmore Field on KTLA in the late 1940s and basketball from the Pan Pacific Auditorium. Vin Scully (middle) came west with the Los Angeles Dodgers in 1958. For the first few years, only the Dodger games from San Francisco were viewed on Channel 11. Chick Hearn (left) joined Channel 4 in 1958 to do a nightly sports report and then went with the Lakers. Tom Harmon and his wife, Elyse, had a show on Channel 9, and then he moved to Channel 5 to do sports on the evening newscasts. His family group shot at top right includes his daughters Chris and Kelly and his son Mark, star of NCIS. (All, courtesy of *TV-Radio Life*.)

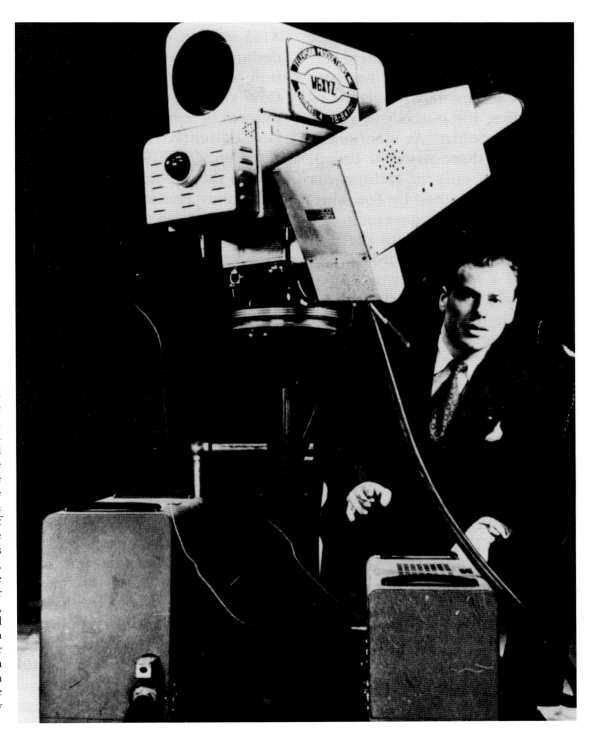

Klaus Landsberg produced and directed all the major KTLA productions. He was also the station manager, programmer, chief salesman, talent scout, and chief engineer. He was also a heavy smoker. Cancer invaded his body, and he had many operations. Often, he would be driven to a show's set in an ambulance, produce and direct the program, and then return to the hospital. He told his remote supervisor, John Polich, "They can take a knife and cut off my arms and legs. Just leave my head." The next day, Landsberg died. His contributions to television could have filled a long lifetime, but when he died on September 16, 1956, he was only 40 years old. Tom Moore, the former president of ABC, spoke for many, saying, "Klaus Landsberg was a genius. Television will always carry with it his influence." Although there was never a proven connection, four KTLA engineers who had covered the atom bomb blast died of cancer at early ages in addition to Landsberg, whose motto was, "The impossible takes a little longer." (Courtesy of KTLA.)

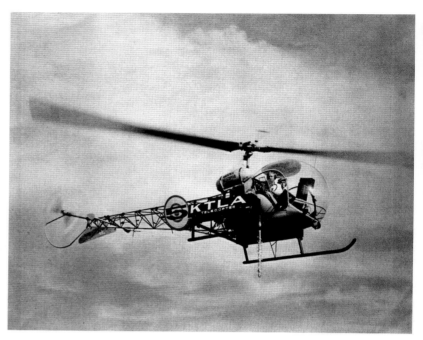

In 1956, KTLA was doing a live remote from an aircraft carrier in the harbor. A high shot was needed to show the enormity of the ship. There was only one way to do it. A full-size camera was carefully loaded into a helicopter, and the camera cable was dropped out the door as the copter went higher and higher. The hundreds of feet of cable went to the remote truck on the dock, enabling the live high shot of the carrier to get on the air. This was the genesis of the world's first live television helicopter. KTLA engineer John Silva, along with Roy White, started working in complete secrecy to develop the new invention. The first helicopter was a rented Bell 47. (Left, courtesy of KTLA.)

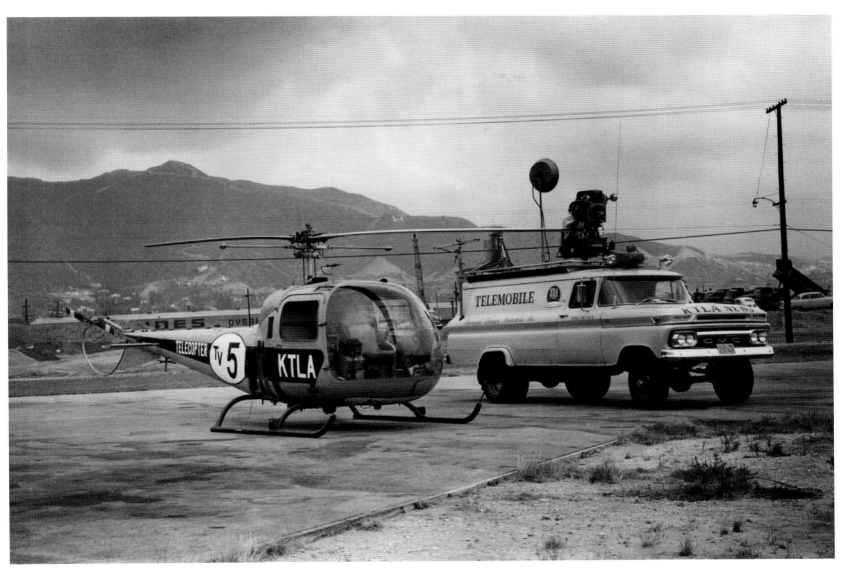

The camera had to be small. The microwave dish, which would send the live pictures to Mount Wilson, had to be light. Working in a secure garage, the project was finally done, and on July 3, 1958, the KTLA Telecopter was unveiled to the world. It would change the coverage of news forever, but it would be another 10 years before another station would have a live news helicopter. A second-generation copter was unveiled a couple of years later. Also developed was a complete ground unit called the Telemobile. It could broadcast live pictures as it was in motion. On its first test run up a hill, the unit fell on its two back wheels, as the equipment in the rear was too heavy. One of the initial plans for the Telecopter was to have a huge light on its undercarriage. When there was breaking news, the light would flash, alerting viewers to go into the house and tune into Channel 5. That plan never developed. (Courtesy of KTLA.)

Clete Roberts's specialty was international reporting. First on the radio and then on Channel 13 in the early 1950s, he found himself in Hungary and Suez where news was happening. He was at Channel 2 in 1958 when KTLA called. Its news director and anchor Gil Martyn had lost his ability to speak because of cancer, another possible victim of the atom bomb coverage. Roberts was hired as part of The Big Three News along with Bill Stout and Tom Harmon. It quickly became the number-one local newscast. Each half-hour broadcast consisted of 15 minutes of news, five minutes of Stout's investigative reports, five minutes of Harmon's sports, and a five-minute Roberts commentary. He would remain at KTLA until 1962, when he returned to Channel 2. (Left, courtesy of TV-Radio Life; above, courtesy of KTLA.)

In the fall of 1959, Russian premier Nikita Khrushchev visited the United States. On September 19, 1959, the State Department arranged for him and his wife to visit the 20th Century Fox studios in West Los Angeles to view a pivotal scene being shot for the film *Can-Can*, starring Frank Sinatra, Shirley MacLaine, and a bevy of scantily clad can-can dancers. Owing to strict union rules, only KTLA was allowed on the 20th lot but fed the live coverage to all the networks. Clete Roberts, pictured directly under the camera lens, was the reporter. Asked what he thought of the scene he viewed being filmed, Khrushchev replied, "It was exploitative and pornographic." (Courtesy of KTLA.)

One of the most unusual news anchors in Los Angeles was Baxter Ward. He started on Channel 13 in the mid-1950s and then moved to Channel 7 and finally Channel 9. He recalls that when he moved over to Channel 7, there were only three people working in the news department. He became the fourth. Ward drove the show directors crazy because he ad-libbed his entire newscast. It was more a conversation with the viewers than a reading of a teleprompter. There was no one like him before or since. In 1969, he quit broadcasting to run for mayor and lost; one of the reasons might have been due to the fact that he was a germaphobe and feared shaking hands. He did, however, win two terms as a Los Angeles county supervisor in the 1970s. (Both, courtesy of *TV-Radio Life*.)

THE NEWS WARS

In 1961, KNXT Channel 2 changed the local news game forever. Led by news director Sam Zelman, the station started a 45-minute local newscast with the 15-minute network news taking up the rest of the hour. The program was called *The Big News*. There were no large sets, just medium shots of the various newscasters at podiums. The main anchor was Jerry Dunphy, and the rest of staff included weather with Bill Keene, sports with Gil Stratton, and features with Ralph Story, Maury Green, Robert Simmons, Saul Halpert, and others through the years. There was no chitchat between the news team or theme music—just pure news. Los Angeles had just lost two of its four daily newspapers, so audiences were hungry for more news. *The Big News* had bureaus in Sacramento, Washington, DC, and Orange County.

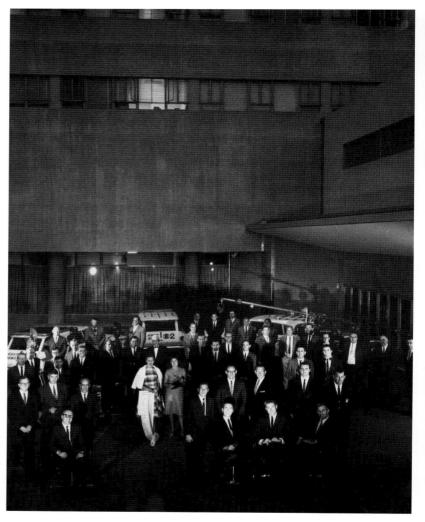

By September 1963, *The Big News* expanded to an unprecedented one hour of local news followed by the expanded 30-minute network news. One Channel 2 staffer asked, "How are we going to fill an hour?" Soon, the program was getting ratings equal to prime-time audiences, and there would be no going back. In 1968, KNBC Channel 4 expanded to two hours of local news, and Channel 7 then went to two-and-a-half hours. Sam Zelman had proven you could do longer newscasts and make money as well. *The Big News* staff is seen here in the Columbia Square entranceway.

The first big story covered by the Telecopter started on the morning of November 6, 1961: the Bel-Air Fire. The Santa Monica Mountains were ablaze, and 456 of some of the most expensive homes in the city were lost. Channel 5's coverage from the air and the ground lasted 19 hours. The copter, with pilot-reporter Larry Scheer and cameraman Harold Morby, along with Clete Roberts, Bill Stout, and Stan Chambers on the ground, brought the story live to the country. At one point, Clete Roberts's nearby home was accidentally bombed with fire retardant. (Both, courtesy of KTLA.)

After Clete Roberts's departure from KTLA, the station realized it had to do something bold to recapture its news audience from Channel 2, so it hired Channel 2 news director Sam Zelman to create the same kind of magic for KTLA. Zelman put together an on-the-air team consisting of Robert Arthur from KNX radio, Tom Snyder from Savannah, Joseph Benti from Kansas City, as well as KTLA holdovers Bill Stout, Terry Drinkwater, and Tom Harmon. The new broadcast, simply called _the_ news, premiered on April Fool's Day in 1963. Pictured from left to right are Sam Zelman and Bill Stout. (Both, courtesy of KTLA.)

The station tried everything to make the show work. It changed the start time from 6:30 p.m. to 7:00 p.m. to 5:30 p.m. It switched main anchors from Robert Arthur to Joe Benti. It did special extended reports: "Our Next Earthquake!" But the expensive show never caught on, and by the fall of 1963, Zelman returned to CBS. Later he would be one of the architects of CNN. One by one, the other personalities were gone. Things did not recover until KTLA hired Hal Fishman away from Channel 13 and George Putnam away from Channel 11 in 1965. Pictured here are, from left to right, Robert Arthur, Bill Stout, and Joseph Benti on their way somewhere.

Tom Snyder is seen here with the Special Coverage Unit, the predecessor to the Telemobile. (Courtesy of KTLA.)

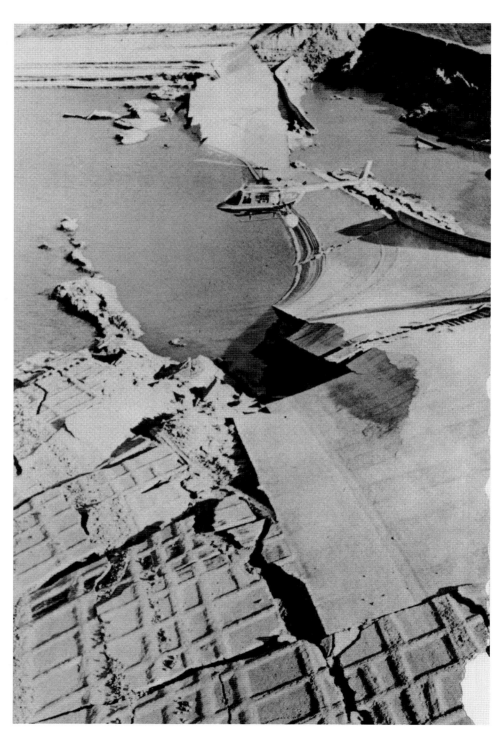

On a beautiful Saturday afternoon, December 16, 1963, a dam in the Baldwin Hills collapsed, sending thousands of gallons of water cascading through a residential and shopping area in the city. Cars were washed downstream, and houses were ripped from their foundation. As KTLA anchor Robert Arthur reported, "It was a day unsuited for tragedy." In the Telecopter were backup reporter-pilot Don Sides and cameraman Lou Wolf. On the ground were reporters Tom Snyder and Terry Drinkwater. All the other Los Angeles stations were given permission to carry the coverage, as well as the three networks and Canada's CBC-TV. (Courtesy of KTLA.)

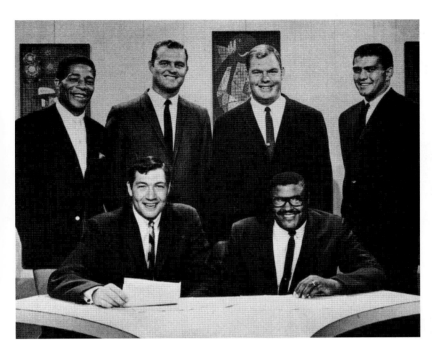

When Gene Autry, the Angels baseball team owner, bought Channel 5 in 1964, he thought it would be a good idea to have professional athletes deliver the sports news, so he hired, from left to right, (first row) Rudy La Russo from the Lakers and Rosie Greer from the Rams; (second row) Willie Davis and Don Drysdale from the Dodgers and Merlin Olsen and Roman Gabriel from the Rams. Autry also hired Jim Fregosi, Jim Piersall, and Bob Rodgers from the Angels and Elgin Baylor from the Lakers. It did not work out well. Their segments had to be pre-taped because of their nervousness and difficulty reading scripts, but it did work out for one person—Dick Enberg was then hired as the sportscaster. (Above, KTLA; right, Rothschild Photograph.)

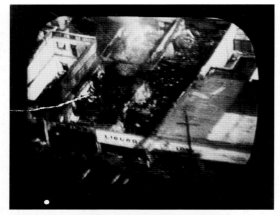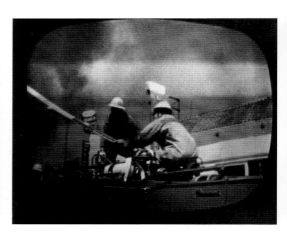

On August 11, 1965, the Watts Riots started in the South Central area of Los Angeles. Fires broke out, and looting was prevalent. The disturbances lasted for six days and caused 34 deaths and $40 million in property damage over an area of 46 square miles. The KTLA Telecopter covered the story. Looters were shown in the act, and gunshots from the ground were aimed at the Telecopter to keep it from identifying the criminals. Harold Morby (left) and Larry Scheer are pictured in the Telecopter. (All, courtesy of KTLA.)

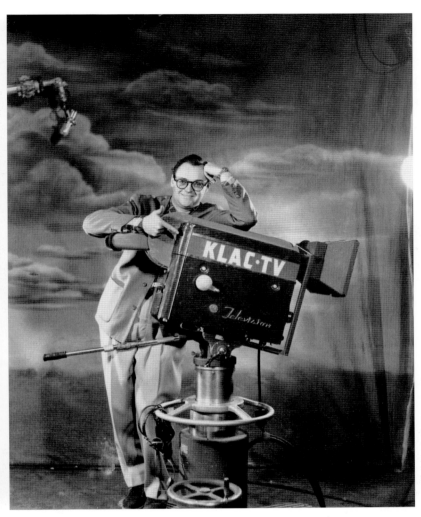

Research through the years has shown consistently that the most popular members of the news teams have been the weather forecasters. At Channel 2, Bill Keene had his "schoolometer" telling parents what the kids should wear the next day to school. (Courtesy of Jerry Fitzgerald, CBS.)

Jim Hawthorne had a nightly show on Channel 13 and did zany weather forecasts for Channels 4 and 5. (Courtesy of Mitch Waldow.)

Wheel of Fortune host Pat Sajak was the Channel 4 weatherman in 1980 and was also utilized for rating-period sweeps pieces like "Bargains." He followed Channel 4 weathercasters Gene Bollay, Gordon Weir, Lee Giroux, Bob Hale, and Kelly Lange. Channel 7's weather team included Dallas Raines, Dr. George Fischbeck, and Johnny Mountain. Channel 2 forecasts featured Maclovio Perez, Austin Green, Harry Geise, and Steve Edwards.

THE NEWS WARS

Channel 4, tired of being regularly beaten by Channel 2, kept reinventing itself. In 1966, it started *The Sixth Hour News*, "90 minutes of news that moves," anchored by Robert Abernethy. Then, in 1968, *The KNBC Newservice* began with Jess Marlow and Peter Burns at 5:00 p.m. and Tom Brokaw at 6:00 p.m., the nation's first two-hour local newscast. The 11:00 p.m. news program was anchored by John Schubeck, with Olympics hero Rafer Johnson covering sports.

Pictured here from left to right in the front row are Brokaw, Abernethy, Marlow, and Burns. (Courtesy of NBC Universal Archives and Collections.)

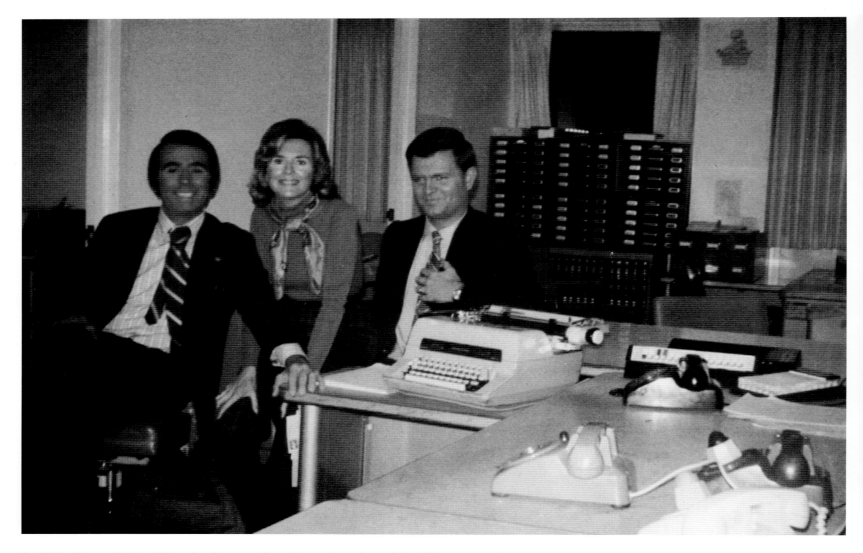

In 1970, Channel 4 hired Tom Snyder away from his anchor job in Philadelphia, where he had wound up after KTLA let him go in 1964. His unique informal style, along with weathercaster Kelly Lange and sports anchor Ross Porter, finally overtook Jerry Dunphy for the 6:00 p.m. audience. Channel 2 decided it was time for a change and wanted to let Dunphy go but did not want another station, particularly Channel 7, to pick him up. On a Friday afternoon in 1975, the general manager at Channel 2 called his counterpart at Channel 7 to see if there would be any interest in hiring Dunphy if his station let him go. The general manager of Channel 7 said, "Why would I want him?" That afternoon, Dunphy's contract at Channel 2 was not renewed. On Monday morning, he was hired by Channel 7. Channel 2's general manager called his counterpart back and said, "You told me you wouldn't hire him." Channel 7's general manager's replay was, "I lied." In 1974, Snyder moved to New York with his *Tomorrow* show. Soon, Dunphy, now on Channel 7, was number one again.

In 1968, Channel 2 wanted to remind viewers that its 11:00 p.m. news could stay on as long as there was news to report. Of course, there was no David Letterman or Merv Griffin following it—only a movie.

Tom Brokaw took over the Channel 4 news anchor desk in 1968, following in the footsteps of Jack Latham, John Schubeck, George Skinner, and Dean Brelis. He held that spot until he became an NBC correspondent and was replaced by Paul Moyer.

Live breaking news from the ground was still difficult in the early 1970s because the cameras were big. Then, in 1974, the groundbreaking minicam was invented. There had been experimental small cameras before, but they were in black and white and the pictures were not sharp. KNXT Channel 2 became the first station in town to replace its news film cameras with video, and so-called "electronic news gathering," or ENG, began.

ENG's first big test came on May 17, 1974: the Symbionese Liberation Army (SLA) Shootout. Los Angeles police had gotten a tip that kidnapped heiress Patricia Hearst and members of the SLA were held up in a house in midtown. Police surrounded the area, and KNXT sent its new ENG crew. In the shootout, over 9,000 rounds of ammo were used and the house was burned down, but Hearst was not found. The whole event was shown live. Cameramen Rey Hernandez and Rich Brito carried the new minicams, which weighed 80 pounds each. Reporters Bob Simmons and Bill Diaz also dodged the tear gas and bullets in the two-hour coverage. The camera and tape machine batteries had to be charged every 20 minutes, and the cables running back to the microwave truck ran for blocks. But it was the first coverage of its kind, and soon, all the stations were dumping their film cameras, which had been used since the beginning of television news coverage.

THE NEWS WARS

In the mid-1970s, the news battles heated up as stations changed ownership, general managers were fired, news directors were replaced, time slots and formats changed, anchors switched stations, and promotion departments tried every approach. One reporter told another, "If my boss calls, get his name." Sportscasters became news anchors. Both Jim Lampley and Brent Musberger went from sports to news and then back again to sports. Bryant Gumbel handled sports at Channel 4 and then went on to anchor *Today*.

Hal Fishman and George Putnam, who were together at Channel 5, became fierce competitors for the 10:00 p.m. audience.

THE NEWS WARS

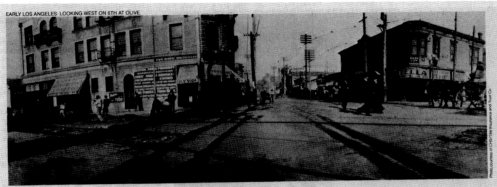

There was a time when all the news in Southern California could be told in 15 minutes.

A quieter time. A simpler time. But it wouldn't stay that way for long.

Because Southern California was a paradise that eventually attracted millions from all over the world. They brought different hopes, dreams, skills and ideas. They created one of the world's unique communities.

And in the process, created more of those events which we call: news.

Suddenly, all the news in Southern California *couldn't* be told in 15 minutes. Or in 30 minutes. Or even 45.

Which is why, in 1963, KNXT Los Angeles introduced the nation's first one-hour news broadcast. And made television history.

And why, on June 19 of this year, we introduced the country's first 2½ hour TV news as well as Southern California's only 4:30 Early News.

And made history again.

All reflect our continuing commitment to inform you of a changing world. A more complex world. A world rich with diversity. Rich with people. An expanded world filled with more events, more news than ever before.

But it not only takes more time to report it than ever before, it also takes more people. The right people.

Like Connie Chung, Joseph Benti and Mike Parker. Linda Douglass, Bill Stout and Steve Edwards. Ralph Story. Brent Musburger, Jim Hill and David Sheehan.

They make it more than just 2½ hours of news.

They make it 2½ hours with news professionals.

CHANNEL 2 NEWS AT 4:30, 5 AND 6PM
KNXT Los Angeles
A CBS Owned Station

Stations tried everything to get audiences to watch their news shows. Channel 7's most famous promotion was "Win a newscast! Have the Eyewitness News Team join your family." The winner got the anchors to broadcast the news from the family's living room. Channel 2 tried a set that revolved on a turntable every 20 minutes, and then promised one of its news shows would only feature "good news." Channel 5 hired the former police chief Tom Reddin to anchor its newscast. Channel 13 had its anchors walking around the newsroom for the entire show.

John Schubeck returned to Channel 4, and Tritia Toyota joined Jess Marlow at 5:00 p.m. Kelly Lange went from the weather to coanchoring with Paul Moyer at 6:00 p.m.

Jess Marlow moved to Channel 2's Action News to coanchor with Colleen Williams.

In 1977, Connie Chung coanchored with Maury Povich at Channel 2. Povich later moved on to *A Current Affair* in New York, and when Chung later moved East, they married. Also at Channel 2, Jim Lampley and Bree Walker coanchored and later married.

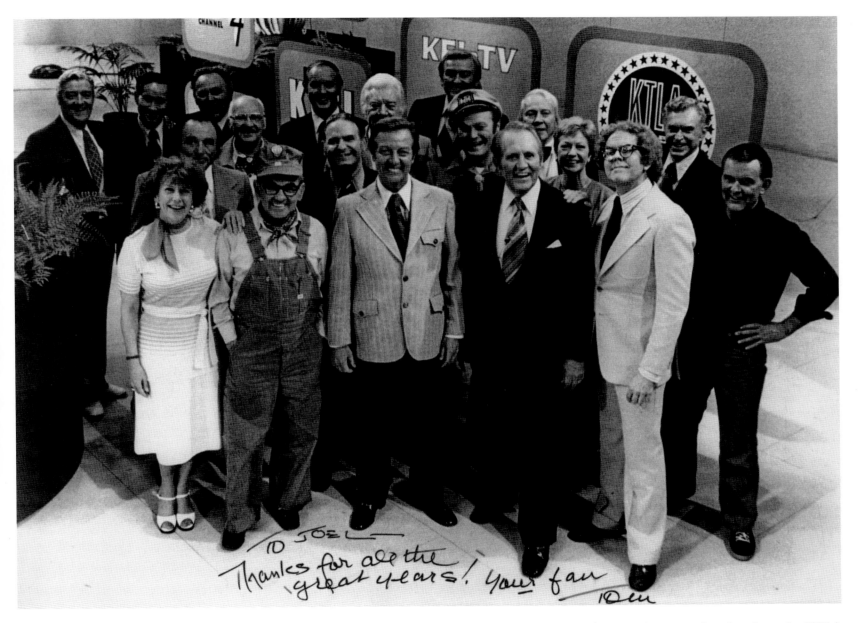

In January 1977, approximately 19 Los Angeles television pioneers gathered on Stage 6 at KTLA for the taping of a two-hour special celebrating the first 30 years of local television. Pictured from left to right are (first row) Mary Parks (Miss Mary) of *Romper Room*, engineer Bill Stulla, Mike Stokey, Art Linkletter, Stan Freberg, and Tom Hatten; (second row) Paul Coates, Harry Owens, Eddie Gevertz, Skipper Frank Herman, Criswell, Dorothy Gardiner, and Dick Garton; (third row) Jack Rourke, Peter Potter, Cliffie Stone, Stan Chambers, Jack Latham, and Charlie Stahl. (Courtesy of KTLA.)

Things came full circle for Johnny Carson on April 3, 1979. He returned to Channel 2 after 25 years to surprise Ed McMahon on McMahon's 40th year in show business being celebrated on *The Steve Edwards Show*.

THE NEWS WARS

(Advertisement)

WATCH THE TEAM TO WATCH ON 2

AS THE world becomes more complex, knowing all the news is more important—and more difficult—than ever. People value experienced journalists who know how to get it all and give it to you straight. In Southern California, Channel 2 News is The Team to Watch.

"I'll always consider myself a reporter first," says Connie Chung, "and as an anchor, I draw heavily on my field experience." Jess Marlow says of his 20-plus years in Southern California television news, "People build trust in you over time. I take that responsibility very seriously."

Sandy Hill, the newest member of the team, brings a unique perception of human nature to her work. "I'm drawn to stories that celebrate people. They're an important facet of the news." Veteran newscaster Ralph Story uses his 30-year insider's view of the Southland. "It's not just news. It's real people, real places. Knowing the territory helps you communicate."

Sportscaster Jim Hill has a former pro athlete's outlook that guarantees his subjects a fair shake: "You've got to be honest both with the people you're talking to and the ones you're talking about."

Weatherman Maclovio Perez let's his professional training and technical equipment work for him. "People want to know how the weather's going to affect them. My job is to interpret." Commentator Bill Stout says his nightly Perspective isn't aimed at making people see things his way. "I just want to get them thinking about the issues."

Experienced journalists, plus a top-notch team of professionals on both sides of the camera. They're what's making Channel 2 News The Team to Watch.

CBS 2 KNXT/LOS ANGELES

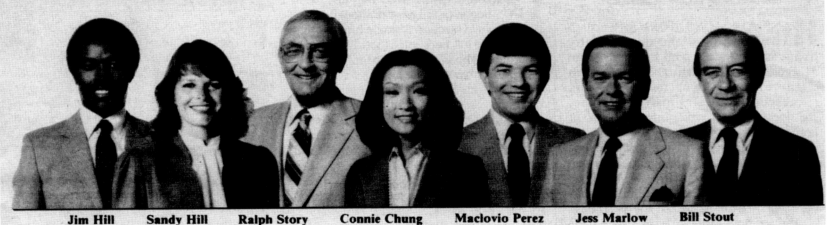

Jim Hill Sandy Hill Ralph Story Connie Chung Maclovio Perez Jess Marlow Bill Stout

This was the Channel 2 news team in 1980 after the station had gone to two-and-a-half hours of local news.

The early-1980s Channel 7 news team included, from left to right, John Schubeck (formerly of Channel 4), Ralph Story (formerly of Channel 2), Keith Jackson (formerly of Channel 5), Alan Sloane (formerly of Channel 13), Joe Benti (formerly of Channel 5), and Stu Nahan (formerly of Channel 4). (Courtesy of James Wood.)

THE NEWS WARS

The Channel 4 news team in 1986 featured, from left to right, weathercaster Fritz Coleman, anchors John Beard and Kirstie Wilde, and sportscaster Fred Roggin. Coleman and Roggin are still at the station. (Courtesy of NBC Universal Archives and Collections.)

LOS ANGELES TELEVISION

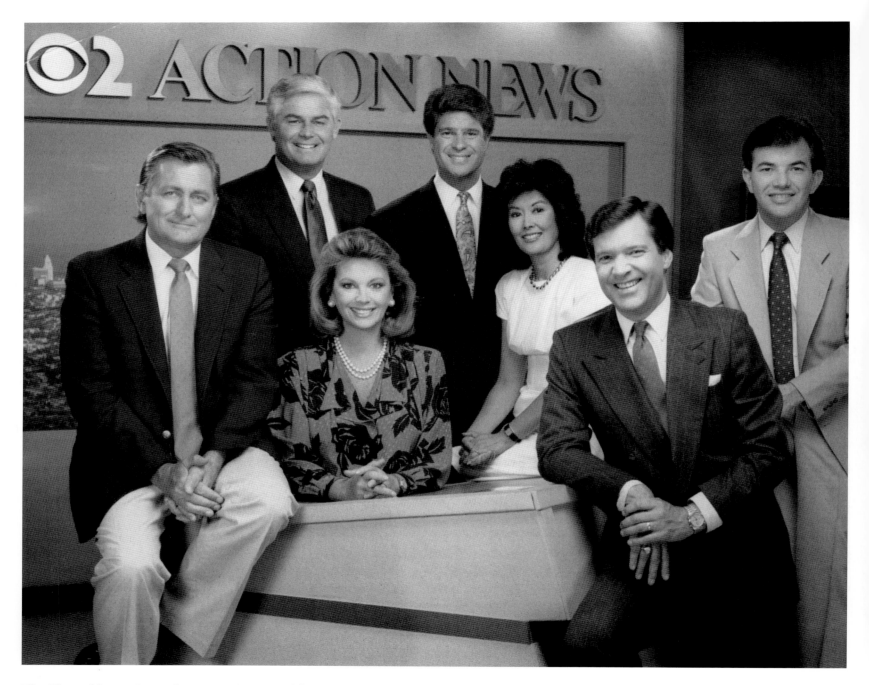

The Channel 2 team is seen here in 1988. Pictured from left to right are John Schubeck, Kevin O'Connell, Terry Murphy, Jim Lampley, Triria Toyota, Chris Conaglia, and Maclovio Perez.

Just after midnight on March 3, 1991, George Holliday was trying out his new video camera on his balcony in Lakeview Terrace. Across the street, he noticed police cars and started aiming his camera at the event. Los Angeles police appeared to be beating an African American man named Rodney King. After the incident, Holliday called CNN to report what he had on video. It was late Sunday night, and no one answered the phone at CNN, so next he called the KTLA Newsroom, which was open. KTLA bought the tape and aired it. The officers were subsequently charged, and on April 29, 1992, some of them were acquitted. The verdict led to rioting, which stretched from downtown to Hollywood. Fifty-three people were killed in the riots. (Courtesy of KTLA.)

Around 1990, the early-morning time period in local television became the fastest growing revenue earner of the whole broadcast day. When people woke, they wanted local traffic, weather, and news, which the morning network shows presented in small doses. In July 1991, Channel 5 began *The KTLA Morning News* with a cast few people had heard of before. The original team consisted of, from left to right, (top row) news anchors Carlos Amezcua and Barbara Beck, weather forecaster Mark Kriski, and field reporter Michele Ruiz; (bottom row) field reporter Eric Spillman, entertainment reporter Sam Rubin, helicopter reporter Jennifer York, and business reporter Jim Newman. Sharon Tay (second from the left) and Gayle Anderson (fourth from the left), seen below at a remote from Dodger Stadium, were added to the team later. (Both, courtesy of KTLA.)

THE NEWS WARS

On the morning of June 13, 1994, the stabbed bodies of Nicole Simpson and Ron Goldman were found in Brentwood. Thus began a new chapter in television news coverage: the helicopter pursuit. Four days later, O.J. Simpson, suspected in the killings, was a passenger in a Ford Bronco on the San Diego Freeway being chased by authorities for questioning. It was a slow-speed pursuit, but soon, most of the television helicopters in town were following every moment. Channel 4 even did a split screen with the pursuit and an NBA playoff game. The next day, the ratings showed there were 95 million people watching the pursuit across the country. From that point on, pursuits became almost required coverage by stations. The other outcome, from then on, was that competing stations could take each other's feeds when their helicopter needed to refuel and a pursuit or other breaking news was still in progress. That cooperation had never happened before.

Just before O.J. Simpson's trial for murder was scheduled to begin, the general managers of all seven stations got together to figure out the best way to cover the proceedings. It was agreed that for the first day, all stations would cover it, and afterward, the coverage would rotate to a different station each day. After the first few days of rather benign testimony, most of the stations opted out of the deal. KTLA decided it would go gavel-to-gavel for the entire length of the trial. Since the station's usual daytime ratings were terrible, it made sense. On the day of the verdict, all stations once again joined in on broadcasting the event.

In 1997, Channel 5's Stan Chambers celebrated his 50th anniversary at the station. As part of the event, a surprise reunion was held with some of his colleagues from 1947 to 1950. Pictured from left to right are Bud Stefan (*Yer Old Buddy*), Dorothy Gardiner (*Handy Hints*), Stan, John Milton Kennedy (*Armchair Detective*), Bill Welsh (*Meet Me in Hollywood*), and Ken Graue (*City at Night*). In 2012, Chambers retired after 65 years at one television station, a record never to be equaled. The main studio administration facility was named the Stan Chambers Building.

This is a rare combined shot from 1999 of the air personalities of *The KTLA Morning News* and *News at Ten*. They hardly ever saw each other because their shows were scheduled at opposite sides of the day. Pictured from left to right are Emmett Miller, Sharon Tay, Mark Kriski, Carlos Amezcua, Sam Rubin, Giselle Fernandez, Hal Fishman, Mindy Burbano, Lynette Romero, Larry McCormick, and Marta Waller. (Courtesy of KTLA.)

THE NEWS WARS

Of the original seven Los Angeles television stations, none are still in locations where they began. Channel 2 and 9, which shared space on Vine Street from 1951 to 1960 and then went their separate ways, are back together. Both now owned by CBS, they are housed at CBS Studio Center in Studio City on the former Mack Sennett movie lot. Ironically, it was Sennett who originally wanted to buy but could not afford the land atop the Hollywood sign that became the home of experimental station W6XAO. Today, in the combined Channel 2 and 9 Newsroom, is a plaque and pictures honoring both stations' number-one anchor, Jerry Dunphy. (Below, courtesy of Jake Lau.)

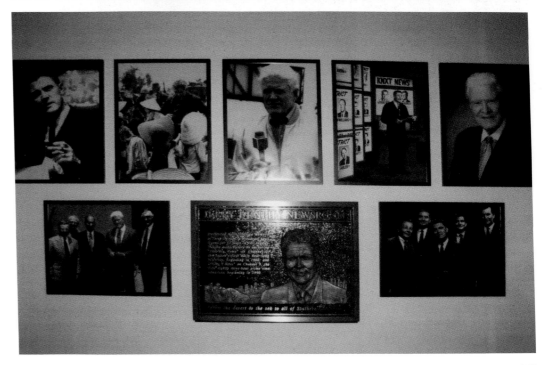

LOS ANGELES TELEVISION

Channels 11 and 13, now both owned by Fox, share space in West Los Angeles on Bundy Drive.

Channel 4 is now housed in buildings on the Universal lot in Universal City. There is a local studio and a network studio, and the whole facility has been named the Brokaw News Center in honor of Tom Brokaw.

Channel 7, owned by Disney, now broadcasts from a facility in Glendale.

Currently KTLA remains at the Sunset and Van Ness location it has occupied since 1954. It was here in 1927 that Warner Bros. shot *The Jazz Singer* with Al Jolson, the first motion picture in which spoken dialogue was heard. In the 1960s, CBS's *Gunsmoke* and NBC's *Get Smart* were produced here.

Among locally produced broadcasts that have mostly disappeared are children's shows, variety programs, public affairs shows, and station editorials; look for them only in books. In 2013, KCOP Channel 13 became the first of the original stations to cancel its newscasts. On the other end of the scale, *The KTLA Morning News*, once two hours long, now runs from 4:00 a.m. to 10:00 a.m. As for the others, stay tuned.

Los Angeles television has had a most interesting journey since 1931. Dorothy Gardiner, one of the first KTLA stars, recalled that whenever anything went wrong on a broadcast, which frequently happened, a crew member would tell her, "Don't worry about it . . . we're pioneering."

DISCOVER THOUSANDS OF LOCAL HISTORY BOOKS FEATURING MILLIONS OF VINTAGE IMAGES

Arcadia Publishing, the leading local history publisher in the United States, is committed to making history accessible and meaningful through publishing books that celebrate and preserve the heritage of America's people and places.

Find more books like this at
www.arcadiapublishing.com

Search for your hometown history, your old stomping grounds, and even your favorite sports team.

Consistent with our mission to preserve history on a local level, this book was printed in South Carolina on American-made paper and manufactured entirely in the United States. Products carrying the accredited Forest Stewardship Council (FSC) label are printed on 100 percent FSC-certified paper.

EXTRAORDINARY POOLS

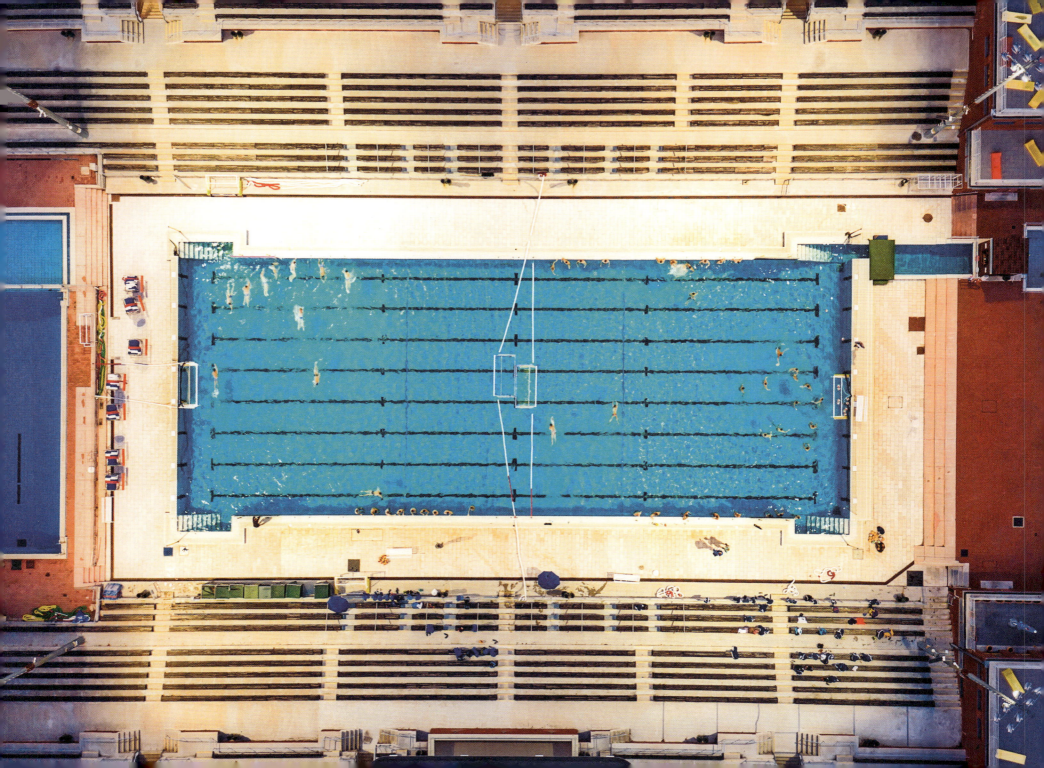

EXTRAORDINARY POOLS

NAINA GUPTA

PA PRESS

PRINCETON ARCHITECTURAL PRESS · NEW YORK

Contents

Phantom Pools, Naina Gupta 6

1. Progressive Visions 12

2. A Matter of National Importance 36

 Mussolini's Boys:
 Muscles, Messages and Mosaics

3. A Pool with a View 60

 Deep Diving:
 Half Air, Half Water, A Fantasy

4. A Very Private Affair 90

5. 'Natural' Pools 106

6.	Free Form, Free From	124
	Concrete, Tiles and Coping: *How Skateboarders Fell in Love with the Swimming Pool*	134
7.	Pool Culture	152
8.	In Suspension	172
	Domestic Monument	184
	Where to find the pools	198
	Index	200
	Further reading	204
	Acknowledgements	206
	Picture credits	207

Phantom Pools

Naina Gupta

The architectural historian Thomas van Leeuwen observes that swimming is possibly the closest a human being will come to experiencing the sensation of flying. Swimming is a learned movement – it is different from what we consider our natural stance to be. Therefore, the question then arises: how does swimming inform the design of the space and in turn, how does the space enable and enrich this way of moving? What is the role of architecture in swimming pools? The projects that have been profiled in this book have in different ways contributed to these questions. Swimming allows one to move in ways that are simply not possible on land. Moving in water – skimming or floating on the surface; suspended in it with a 'frog's-eye' viewpoint of the world; penetrating it as one dives in; or piercing through it underwater – at the least fosters new ways of exploring space physically, visually and textually. The potential that it opens is what I believe makes for extraordinary pools in architecture. Even after being contained, water is anything but predictable. The nature of water as a material, as an effect and as an inhabitable space, fires the architectural imagination where reflection, transparency, fluidity and immersion continually birth new ways of interacting with the space. In this introduction, I am going to talk about the relationship between the swimmer and the architecture of the pool, using examples of some of the pools – real and imagined – that exert their presence phantom-limb-like on the architectural history of swimming pools.

On the surface, a pool is a deceptively simple object – a shaped hole in the ground. One of the more legendary swimming pools in architecture was exactly this – a circular hole in the ground that was an afterthought. In 1937, Moscow announced Boris Iofan's winning design for the towering Palace of the Soviets. Construction stopped in 1941 and did not resume after the war. Instead, in 1958, the 130m (426ft) diameter hole was filled with water, creating a sport and recreation destination simply called the Moskva Pool. The pool was divided into wedges that

were segregated by sex. An Olympic set-up graced its centre, which included a soaring A-shaped diving structure that framed views across the diameter; most likely axially with the bridge across the river. There are just enough people outside the Soviet Union who have swum in this pool to help to keep its mythical status intact. One of the beautiful stories I heard was about a swim enveloped in rising steam and falling snow in the bitter Moscow winter. Today, the pool has been replaced by the Christ the Saviour Cathedral.

Beneath their shadowy depths, swimming pools conceal a powerful space of imagination where spatial, socio-political, physiological and psychological constructs are being continually constituted and challenged. Where does a pool begin? Is it at the surface of the water or the edge of the basin? Or perhaps it begins at the point where one gets the faint but distinctive whiff of chlorine? The key elements that constitute a pool include the basin, the changing rooms, diving structures, ladders and, to a lesser extent, depending on the type of pool, tiled surfaces, the black line and a clock. This already rich palette is compounded by minute, even invisible, textural qualities that incessantly calibrate the way that our body moves and perceives space. The near-naked swimmer's skin is in direct contact with and sensitive to materials, temperature, vibrations, colour, sound and smell – all of which

are intertwined, leading to a feeling that every pool is unique, and every swim is slightly different. Swimmers have favourite pools and pools that they do not return to. Some swimmers swim only in 'their' pool, content with the novelty that each day brings. For others, pool hunting and all the physiological and psychological response that it incites is part of their swim make-up. Most swimmers lie in between those two extremes. Then there is the category of the non-swimmer pool hunters – the Insta swimmers – who play an equally important role in swimming pool architecture: they motivate innovation and, inadvertently, support architecture.

There is an almost childlike sense of wonder and exploration in swimming – the colours of sunrise and sunset on water, swimming in the moonlight, looking a duck in the eye or hovering above a city – which provokes an equally playful response in the architect/artist, where small inclusions, changes, tweaks and innovations build upon known experiences to create new ones, which in turn are complemented by material advancement and technical expertise. The richness of the palette – materially, experientially and as a social project – is an essential part of the fantasy of designing a swimming pool.

An empty pool is a sad object. Of course, one cannot swim without water; but it is more than that. What is a pool without water? It is surely not a hole. A hole implies that it can be filled, though there have been many attempts to fill an empty pool with other functions; however, its emptiness shadows everything else that is there, except in the rare example, when it births something else such as skateboarding or, perhaps, ice skating. Water gives a pool a function, it gives it colour, and it brings the composition together. Moreover, it gives it a scale – the tiles in a pool are scaled in consideration of a swimmer's speed, gaze and body. Water connects and separates a pool from nature. Azure, the infamous abandoned pool deep in the heart of the nuclear disaster zone in Pripyat in Chernobyl (pictured opposite) was potentially an extraordinary pool. Its yawning jaw-like concrete building opened the swimming hall to natural light and vegetation. Twelve years after the disaster, the pool was finally abandoned when the liquidators left the site – a void in the fabric of the world symbolized by the void of the pool that is slowly being overtaken by nature.

In plan, swimming pools are organized as concentric rings with numerous one-way paths designed to keep ideas of cleanliness and social propriety intact. The architecture marks a sequence of movement, space and behaviour – dry to wet, clothed to swim-suited, closed to open – that is reversed as one leaves the space. The

centrality of the pool encourages seeing and being seen, which over the decades has included portholes pierced below the waterline or completely glass-fronted pools that instantly transform the swimmer into a mythologized Mer-person. In 1925, Adolf Loos met Josephine Baker in Paris and, unsolicited, drew up a plan of his fantasy house for her. The house is pierced by a double-height, top-lit pool that is surrounded by low passages fitted with glazed panels through which a spectator (he) might catch a glimpse of Baker as she glides past in the water. There is the play of exhibitionism-voyeurism in the design that Loos assumed that Baker would willingly partake in.

There is something intimate and vulnerable about immersing oneself in a shared body of water that does not translate quite the same way in most other spaces. Therefore, pools are spaces with some of the more problematic segregationist policies related to gender and race, which in turn is what makes them vital as they unveil unresolved conflict, forcing society to reconsider its outdated and unhelpful norms. Otto Koenigsberger, a Jewish-German émigré to India, designed a municipal pool in Bangalore in 1940. It was one of his first projects in the country. It is a simple, functional project that is a scaled down version of the lidos that were built in England in the 1930s. There is very little mention of this building in his portfolio, and few images of the project survive in his archives, though he did write to his mother about it; nonetheless, the legacy of this pool in the city cannot be overstated. Housed in the heart of the city close to Cubbon Park, the pool was in use until the 1990s, after which it was demolished. Interestingly, Bangalore is peppered with municipal pools, which is not typical for an Indian city. Now, while the relationship between Koenigsberger's pool and the swimming culture in the city cannot be ascertained, nevertheless, concluding that there is a connection between the two is surely within reason. Koenigsberger's pool was most likely designed as the counterpart to the pools in the many clubs in the city. While the club pools were meant for the people of the empire and, in the words of Salman Rushdie, the 'better sort of Indian', Koenigsberger's municipal pool was meant for the people of the colony.

Social ideas about comfort, disease, safety and ecology are often at odds with each other and contribute to the early demise of the building – pools have notoriously short life spans. Chlorine and condensation eat at the structure; sunscreen plays havoc with the mechanical and biological filtration systems of pools. To boot, diving structures are increasingly being decommissioned in public pools, limiting diving to a spectator sport. The architecture of diving was a space ripe for experimentation that was intimately connected to the development of the skill. Compositionally, its

verticality balances the horizontality of the surface of water, creating a volumetric reading of the pool. Its only role is to support a series of platforms at different heights from which people could spring off into the water below. The variations are infinite – a structural and aesthetic problem waiting to be solved. Springboards still feature in pools deep enough for them, but pools are increasingly becoming shallow, in many ways. In a few decades, we are possibly going to be seeing a generation of swimmers who have never catapulted themselves cannonball-like into a pool or belly flopped painfully on its surface – thereby, learning an invaluable lesson.

Rem Koolhaas and Madelon Vriesendorp were living in New York in the 1970s when they wrote 'The Story of the Pool' (1976). The young couple had a bulletin board populated with postcards of swimming pools. It is likely that many of the pools on that board, built in the 1930s as part of the New Deal, were closing or were in a deplorable condition. In the story, the floating pool in its 'ruthless simplicity' represents the remaining vestige of radical vision in architecture, which by the end of the story suffers a fatal end.